Coney Island

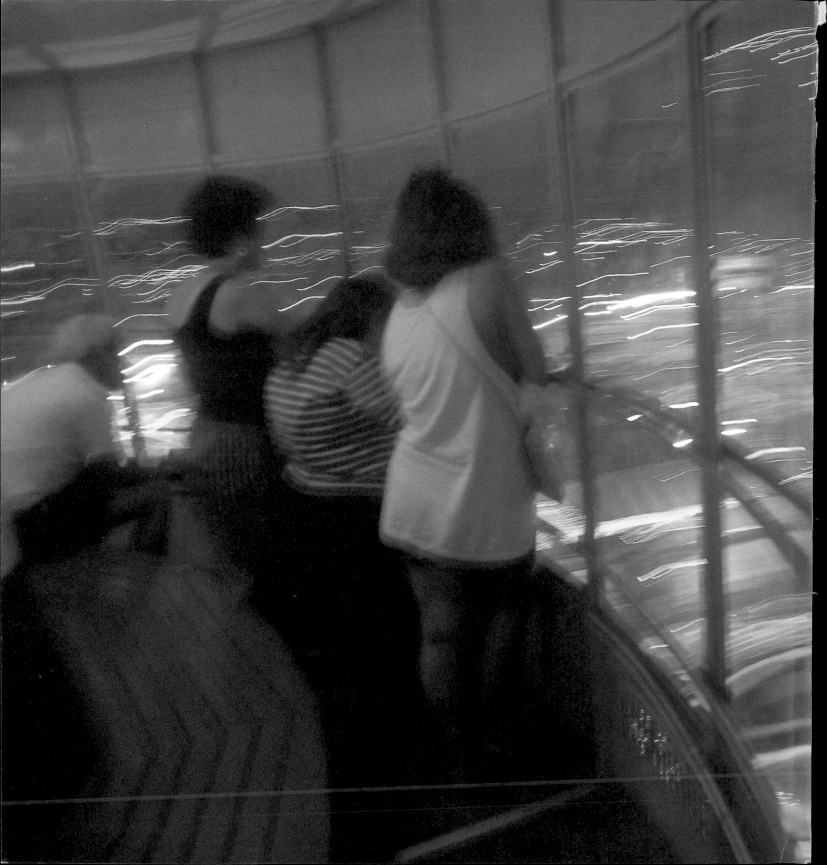

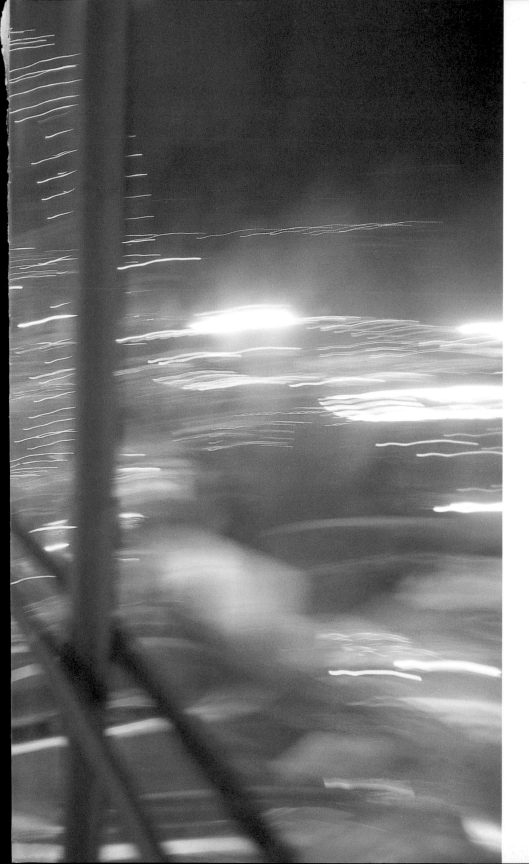

Coney Island

Harvey Stein

Introduction by
David Lindsay

W. W. Norton & Company
New York London

Design by Katy Homans

Library of Congress Cataloging-in-Publication Data
Stein, Harvey, 1941–
 Coney Island / Harvey Stein ; introduction by David Lindsay.
 p. cm.
 ISBN 0-393-04658-3. — ISBN 0-393-31787-0 (pbk.)
 1. Coney Island (New York, N.Y.)—History—Pictorial works.
 2. New York (N.Y.)—History—Pictorial works. I. Title.
 F129.C75S8 1998
 974.7'23—DC21 98-9650
 CIP

ISBN 0-393-04658-3
ISBN 0-393-31787-0 (pbk.)

W. W. Norton & Company, Inc., 500 Fifth Avenue, New York, N.Y. 10110
http://www.wnorton.com
W. W. Norton & Company Ltd., 10 Coptic Street, London WC1A 1PU

1 2 3 4 5 6 7 8 9 0

Nothing is more amazing than the simple truth, nothing is more exotic than our own surroundings, nothing is more fantastic in effect than objective description, and nothing is more remarkable than the time in which we live.

—Egon Erwin Kirch

I grew up in Pittsburgh, Pennsylvania. It is a city I love for many reasons, one of which is Kennywood Amusement Park. As a child, it was always a place of fantasy for me. Faded memories dim the specifics of Kennywood: a small bridge over a manmade lake full of rowboats perhaps; maybe a wooden roller coaster called the Rabbit or the Rocket; a red buggylike car that could almost snap your head off when it went dangerously around a sharp curve. What remains clear is the feel and sense of the place—a carefree, alive, away-from-reality atmosphere that increasingly becomes a luxury as we grow older.

When I was fourteen, my family and I visited friends in Westbury, Long Island. I can remember being awed by New York City—it was too big, noisy, dirty, frightening. But somehow I knew I would live there. One day we visited Coney Island. That, too, was scary and strange, yet fascinating. The Parachute Jump seemed particularly intimidating. But after I saw a little old lady on it, I finally summoned up enough courage to try it. (I was wobbly for at least a week.) Shortly afterward, a fight broke out near us. Two sailors, in white summer uniforms, caps and all, were throwing punches at each other. It was getting dark, and a large crowd gathered. The sailors rolled onto the boardwalk and hit each other over and over again. I had never seen a fistfight between adults before.

Eleven years later, after moving to New York City, I returned to Coney Island with a camera. I've gone back at least a dozen times every year since. It's different from other amusement parks I know. It's multicultural, with people of all shapes, sizes, colors, languages, and behaviors. Absent is the artificiality of American theme parks. There

are no forced enjoyments or phony facades. Coney Island is grimy and authentic, honest and straightforward. It hits you in the face with full force. And it stays in my mind long after I've left, like a movie or song that I can't seem to get out of my head. The only illusion is the easy life it seems to promise with its eternal sun, sand, and ocean. It's where you bring yourself fully into play, rather than being passively manipulated. It's a place where it's all up to you, where you can see the world as it really is and so know yourself as you really are—or ought to be.

Coney Island is a cultural icon of contradictions and complexities, a fantasyland of the past with a seedy present and an irrepressible optimism about its future. It's the poor man's Riviera, the real Disneyland. It's where human polar bears still cavort, mermaids parade, the snake charmer offers up her albino python, and burly men stuff themselves to the max at Nathan's hot-dog eating contest every Fourth of July.

Coney Island is deeply embedded in my soul; I go there to find renewal and inspiration, to meet new people, to witness the astonishing mix of humanity, and to make photographs.

Is it any wonder that photographers are constantly attracted to Coney Island? In the ever-gentrifying milieu of New York City and America, Coney Island remains an oasis of decay, funkiness, hope and joy, uninhibited behavior, and visual stimulation. It has engaged my mind and eye for over twenty-five years. I owe it a great deal. It has endlessly captivated me, tickled my fancy, helped me understand my fellow man, made my life richer and fuller. If only the rest of the world could be a little more like Coney Island.

—Harvey Stein
New York City
1997

Author's Note

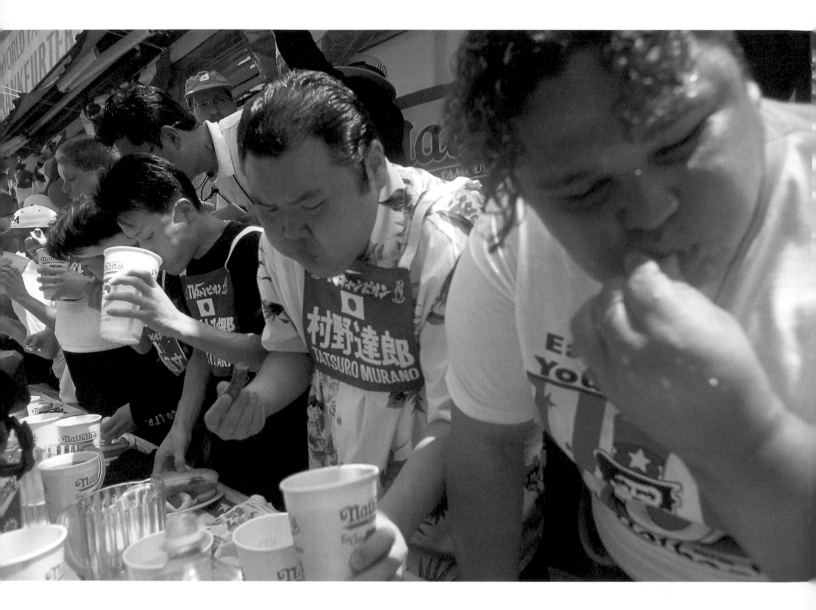

In the first years of the twentieth century, visitors to Coney Island were privy to an astonishing exhibit. A physician named Martin Couney, having found no acceptance for his ideas in the medical community, had installed the first practical baby incubators at Luna Park and, more amazing still, stocked them with honest-to-God premature infants. Spectators gazed in awe at the sight of life beginning at the world's greatest amusement park.

Of course, lives have done more than begin at Coney Island; at one time or another, every important life change has been observed within its borders. Over the years, countless rides have encouraged couples to explore the illicit rites of puberty. Until its closing in 1967, the Parachute Jump provided more than enough danger for any coming of age. Death itself became a Coney Island special when Topsy, an insubordinate elephant, was electrocuted before a paying crowd. And if Milton Berger, guiding spirit of Astroland until his passing in 1997, could not recall when the first wedding took place on the Cyclone roller coaster, I can vouch for at least one occasion in June 1993, because I was the groom perched nervously in the front car, and the vows were my own. Like the Couney babies—indeed, like most living Americans—my life is inextricably bound to the cosmology of the fun house.

How did this small spit of land inspire such a vibrant response to the possibilities of technology? How did it manage to weave the mysteries of human existence so thoroughly into the webbing of the machine? No doubt there are many reasons, but the answer must lie partly in its good timing.

When Coney Island was first becoming a popular resort, the basic principles of Newtonian physics had been mastered but the vast potentials of the electron had not, and in this short span of years, technology showed an uncanny ability to generate crowds. Ford's factories were bringing huge numbers of employees under one roof, where their synchronized movements amounted to a choreography of the Protestant work ethic. In New York, sweatshops were turning entire neighborhoods into machine works writ large, even as the subways were throwing them together and taking them somewhere else.

Given the circumstances of the average American, it's no surprise that Coney Island flourished when it did. The amusement park was the perfect release for the modern laborer—a mechanical carnival for the disaffected, the factory turned on its head. Built from lightbulbs and winches and gears, it spoke to the world in the language of the world, and the word it spoke was "escape."

Then, as now, Coney Island provided an embarrassment of riches for photographers as well. Indeed, those who succumbed to its call must have felt something different, something deeper than the average visitor—not so much the rush of escape as a startling sense of homecoming. Photography, after all, was itself a product of the industrial revolution, involving its own hybrid of social ceremony and technological transaction. In a very real sense, Coney Island and the camera belonged to the same epic story of the machine age.

Certainly, the spirit of Coney was upon photography from the very beginning. François Fauvel-Gouraud, author of the first photographic manual in the United States, was apt to refer to his portraiture subjects as "patients." In the mid-1800s, a large number of daguerreotypists dabbled in the questionable art of phrenology. By 1900, trick photography constituted a genre all its own. All this suggests that photographers would have done well at Coney from quite early on: the lure of an elephant-shaped hotel, which appeared there in the 1880s, comes most immediately to mind. Still, the far edge of Brooklyn was not widely photographed (except perhaps in a primitive sense from the Camera Obscura Observatory, erected in 1883) until the technological moment was ripe.

As it happened, the critical change came from the U.S. Post Office. By 1898, printing techniques had improved and transportation speeds had increased, to the point where the cost of a postcard could be lowered from two cents to one. With this, the picture postcard became economically feasible, and suddenly Coney Island was the among the most heavily photographed locations on earth. On a single day in September 1906, some 200,000 postcards were mailed from Coney Island.

The images burnished upon these cards were mostly of the documentary variety, showing the diminutive trains of Midget City or the triumphal entrance to Dreamland without exaggeration, as if their very existence were evidence enough of a fantastic adventure. (And who could argue with that?) The picture postcard was also a highly democratic format. In mailing one off from the boardwalk, the lowliest of travelers was effectively planting his flag in a thrilling, fictitious country and declaring it his own.

Coney Island never saw a more robust era than it did in the years before World War I. Or, rather, the park got smaller even as attendance continued to grow until eventually the crowd emerged as a subject in its own right. Weegee's famous 1947 image of the beach, carpeted with exultant sunbathers, captures this moment perfectly. At once felicitous and forboding, it projects a one-time Electric Eden on the verge of becoming a fad.

Needless to say, however, that is not what happened. As everyday life became less of a clockwork dance and more of a cathode-ray meditation, Coney pointedly failed to take over the world. By the 1970s, mayoral candidates were still turning up, predictable as the seasons, for candid shots at Nathan's. But for all intents and purposes, the heart of Coney Island had become more symbolic than real.

Except, that is, for those who stayed behind in the mechanical age: the working class of New York, who hauled garments, answered phones, or fixed subway trains for a living, and who, when Memorial Day rolled around, basically had nowhere else to go. These people were less children of the machine than orphans of the silicon chip, and the postcards they sent did not, for the most part, travel to the ends of the earth. Nevertheless, their Coney Island was no less meaningful to them for their plight. Their kisses atop the Ferris wheel were just as sweet, their screams on the Cyclone just as real, no matter how many times Coney's death warrant was signed. Nor, for that matter, did the documentation end with their arrival, because photography kept right on going, too, this time in the hands of more poetically minded practitioners, who saw in

Coney's decayed grandeur the possibility for stunning acts of personal witness.

Who are these people staring out so intently from the pages of this book? The sun shines flat on their imperfections. Often, they are caught alone in the ruins. Even when they're less than isolated, there's little sense that all eyes are upon them, awaiting their next audacious move. Instead, they seem to be operating in a hermetic world, beyond the purview of late-twentieth-century exhortations. The Coney Island shown here is the last outpost of a forgotten culture, where exhibitionism retains its human scale and its original spontaneous flaws.

Yet for all the diminished expectations, these images also reveal a Coney Island that is very much alive. The mermaids who parade down the boardwalk remain defiantly un-Disneyfied. The bathers have no look of putting on airs. The seaside strollers need no guidebooks to find their way. They are still resolutely inside the story of their lives.

Perhaps the most amazing revelation Harvey Stein offers is this: that a way of life could fade from the public consciousness, that it could be jettisoned from the mainstream . . . and somehow continue to thrive. In reaching for a comparison, the imagination runs to the European monarchs who continue to follow the protocols of their majesty in exile, or the Confederate soldiers who fled to the Amazon after the war to raise their children right. And yet this is our own past, following its singular errant branch beneath our very nose.

If there is a word that captures the miracle of this kind of culture, I have not been able to find it. Still, it's undeniably there, season after season, at any given time of day. Perhaps it will come to you as you look at the incomparable Coney Island through Harvey Stein's eyes.

—David Lindsay

1609 Henry Hudson lands on Coney Island; explores New York Bay and Hudson River

1654 Coney Island is purchased for fifteen fathoms of wampum, two guns, three pounds of power

1670 Name of "Conye Eylant" first appears on map

1734 Beach Lane, first road built on Coney Island

1817 Early shelters, pavilions

1824 Coney Island Causeway (Shell Road), toll road, opens

1825 Coney Island House, first hotel, opens

1849 Herman Melville visits Coney Island

1850 Jenny Lind, P. T. Barnum, John Calhoun, Henry Clay, Daniel Webster visit at Coney Island House

1862 Coney Island & Brooklyn Railroad opens horse-car line, first direct public transportation to Coney Island

1863 Surf House (Peter Tilyou)—hotel, restaurant, bath-house—opens

1868 William Engeman purchases Brighton Beach from William Stillwell

1869 Engeman's Pier (William Engeman), first ocean pier, is constructed

1871 Feltman's Restaurant & Cafe (Charles Feltman) opens

1873 Ocean Hotel (William Engeman) opens

1874 Frankfurter is introduced by Charles Feltman

1875 [Thomas] Cable's Ocean House opens

Mrs. [Lucy] Vanderveer's Bathing Pavilion opens

1876 Ocean Park Roadway, a toll parkway designed by Fredrick Law Olmstead, opens for travel between Prospect Park and Coney Island: cost: $300,000. Coney Island property owners protest use of steam trains to replace horse-drawn cars on route from Prospect Park to the ocean.

Coney Island Concourse opens from Ocean Parkway to Coney Island Avenue

West Brighton Hotel & Casino (Paul Bauer) opens

First carousel in Coney Island (Charles Looff) opens at Mrs. Vanderveer's Bathing Pavilion

1877 Manhattan Beach Hotel (Austin Corbin) opens July 4

1878 Iron Tower, former Sawyer Tower, is transferred from Philadelphia Centennial Exposition to Coney Island by Andrew Culver

Old Iron Pier, with bathhouses, shops, restaurants, opens

1879 Sea Side Aquarium opens in Coney Island

1880 Surf Avenue opens from Brighton Beach to West Brighton (today's Coney Island)

Sheepshead Bay Race Track (Coney Island Jockey Club: Leonard Jerome, August Belmont, William Vanderbilt) starts

New Iron Pier, with bathhouses, entertainment, restaurants opens on site of Engeman's Pier by Jacob Lorillard

Charles Looff builds second carousel for Feltman's

The Brooklyn Dance Hall opens in Coney Island

1881 Brighton Beach Race Track (Willaim Engeman) opens

1882 Surf Theater (George Tilyou), Coney Island's first theater, opens

1883 Sea Beach Palace—a rail terminal, hotel, dining rooms, shops, carousel, roller-skating rink—opens

Camera Obscura Observatory, a periscope attraction, opens

1884 First roller coaster is started in Coney Island by LaMarcus Adna Thompson

Elephant Hotel (aka Colossal Elephant) (James Lafferty) opens

Roller coaster (Charles Alcoke), brought from New Orleans fair by Andrew Culver, opens on Iron Pier

1886 Bungarz carousel at Sea Beach Palace opens

1887 Manhattan Beach Bath House is built

1889 "Johnstown Flood" cyclorama opens

1890 Aerial Slide (George Tilyou) is invented

1892 Coney Island Athletic Club is formed, site of future world championship boxing matches

Brighton Beach Music Hall opens

1892 Smith Street trolley, first Brooklyn trolley, from DeKalb Avenue to Coney Island, begins service

1893 John Philip Sousa starts first of many seasons at Manhattan Beach and Brighton Beach

1894 MacKay-Bennett transatlantic cable completed from Coney Island to Hudson River, linking telephones in America to those in Europe

Ferris wheel (George Washington Ferris) is introduced to Coney Island from Chicago's Columbian Exposition by George Tilyou

1895 Sea Lion Park opens (Paul Boyton); first enclosed amusement park with Shoot-the-Chutes, Flip-Flap

Channel Chute roller coaster is erected around deserted Elephant Hotel

1896 Elephant Hotel is burned, destroying Channel Chute Coaster

Brighton Beach Music Hall is wrecked in winter storm; end of Iron Pier disappears; last of the Metropolitan Opera concerts

1897 Steeplechase Park (George Tilyou) opens

1898 City of Brooklyn is consolidated into Greater New York

1899 Gravity Steeplechase Race Course at Steeplechase Park opens

Robert Fitzsimmons, world heavyweight champion, is defeated by Jim Jeffries at Coney Island Athletic Club; Jeffries–Tom Sharkey fight is filmed in Coney Island

1900 Coney Island & Gravesend Railroad, trolley along Surf Avenue from Sea Gate to Manhattan Beach, starts

1901 Loop-the-Loop roller coaster opens

1902 A Trip to the Moon (Frederick Thompson and Skip Dundy) is brought from Buffalo's Pan American Exposition to Steeplechase Park

Sea Lion Park closes

Seaside Park, seventy acres, opens

1903 Luna Park (Frederick Thompson and Skip Dundy) opens with A Trip to the Moon, Shoot-the-Chutes

Topsy the elephant is electrocuted at Luna Park site

1903 Mardi Gras parade is started by Louis Stauch to rebuild the Coney Island Rescue Home (for wayward girls)

1904 Electric Tower is added in Luna Park

Dreamland (William Reynolds, Samuel Gumpertz) opens with Liliputia, Beacon Tower, Dreamland Pier, Streets of Cairo, Santos-Dumont Airship No. 9

1905 Isaac Bashevis Singer visits Coney Island

Kaleidoscopic Tower is added to Luna Park

"Funny Face" logo is developed by George Tilyou

"The Creation" (Henry Roltair) is brought from St. Louis world's fair to Dreamland

Boer War re-creation from St. Louis world's fair opens at Brighton Beach Park for one season only

"Incubator Babies" opens at Dreamland

Thompson and Dundy walk menagerie (elephants, camels, 175 horses, team of bloodhounds) from Luna Park, Coney Island, to Broadway for opening of Hippodrome

1906 Frankfurter is named "hot dog"

Drop the Dip roller coaster (Chris Feucht) opens; is rebuilt in 1908

Maxim Gorky visits Coney Island

1907 Steeplechase fire blazes for eighteen hours; thirty-five acres of buildings are destroyed and are rebuilt the following year

"End of the World According to a Dream of Dante" opens at Dreamland

1908 Ocean Pier at Steeplechase opens

1909 New Brighton Theater opens

Four-hour motorcar and six-day motorcycle racing are introduced at Brighton Beach Race Track

Sigmund Freud visits Coney Island

1910 Sixteen people are hurt on Coney Island roller coaster; twelve people hurt on "double whirl" ride when axle breaks

Pavilion of Fun opens at Steeplechase with swimming pool for men

1911 Dreamland is burned; Iron Tower is destroyed

1911 El Dorado carousel is transferred from Dreamland to Steeplechase; swimming pool for women is added

Dreamland Circus Sideshow (Samuel Gumpertz), freak show, opens

Two women are killed on Giant Racer roller-coaster

House Upside Down, a Steeplechase attraction, is burned

1912 Luna Park changes name of A Trip to the Moon to A Trip to Mars by Aeroplane

1913 Titanic Disaster, reproductions in miniature, opens at Luna Park

1914 Ffity men are arrested for "topless" bathing

1915 Velodrome for bicycle racing opens at Sheepshead Bay Race Track

1916 Eden Musee, wax figures, opens at Coney Island Beach

Nathan Handwerker opens Nathan's

1919 First Yiddish theater opens at Brighton Beach Music Hall

1920 Wonder Wheel (Charles Herman; built by Herman Garms) opens; construction started in 1918

1923 Riegelmann's Boardwalk is opened by borough president

Childs Restaurant, first restaurant on boardwalk, opens

1925 Thunderbolt, roller coaster, is built by George Moran over Kensington Hotel

1927 Half Moon Hotel opens; fourteen stories high

1928 Cyclone, roller coaster (Chris Fuerst and George Kister) opens

1934 Lundy Brothers Restaurant opens in Sheepshead Bay

1938 N.Y.C. Parks Department takes over administration of Coney Island from Brooklyn borough president

1941 Parachute Jump is transferred from "Lifesavers' Exhibit" at the New York World's Fair

1946 Luna Park closes after fire

1947 Coney Island beach attendance tops five million

1954 Feltman's Restaurant is auctioned

1955 New Brighton Theater closes, is demolished

1957 New York Aquarium opens

1964 Feltman's carousel is replaced by Astrotower (250 feet); carousel is moved to Flushing Meadow Park

1965 Steeplechase closes

1966 El Dorado carousel is put in storage; sent to Japan in 1969

1967 Parachute Jump closes

1979 Lundy Brothers Restaurant closes

1980 Coney Island USA founded by Dick Zigun

1981 Lundy Brothers Restaurant and land sold for $11 million

Thunderbolt closes

1983 First Mermaid Parade staged by Coney Island USA

1985 Sideshows-by-the-Seashore opens

1989 Wonder Wheel and Parachute Jump are named landmarks

1991 House under Thunderbolt is partially burned

1992 Lundy Brothers Restaurant is declared landmark; Stauch's Baths is demolished

1997 Cyclone roller coaster's seventieth anniversary—celebrations include women's marathon roller-coaster world record of thirty-six straight hours, set by Michelle Cross, eighteen years old, of Clarksburg, West Virginia

Hirofumi Nakajima of Kofu, Japan, sets new world's record in the eighty-second annual Nathan's Famous Fourth of July Hot Dog Eating Contest: twenty-four hot dogs (and buns) eaten in twelve minutes

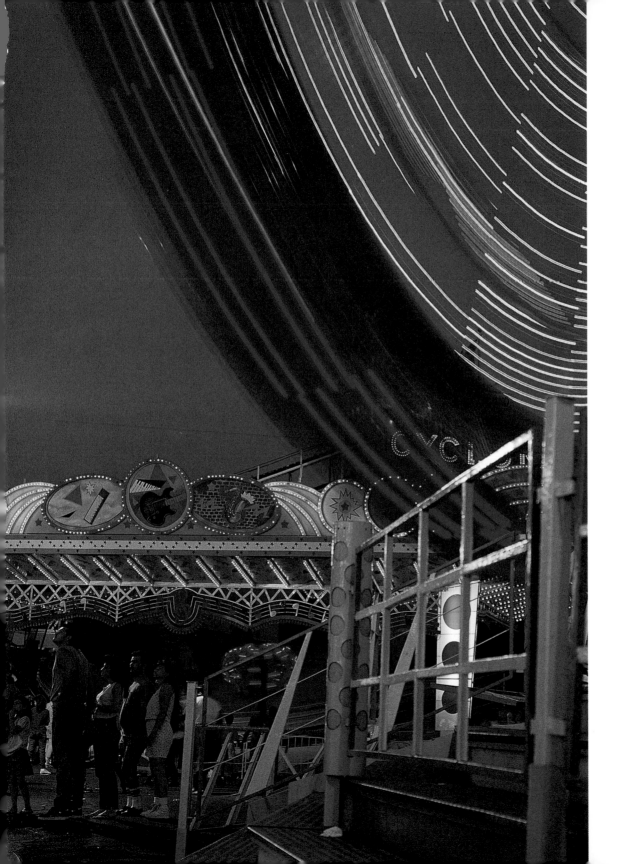

Amusements

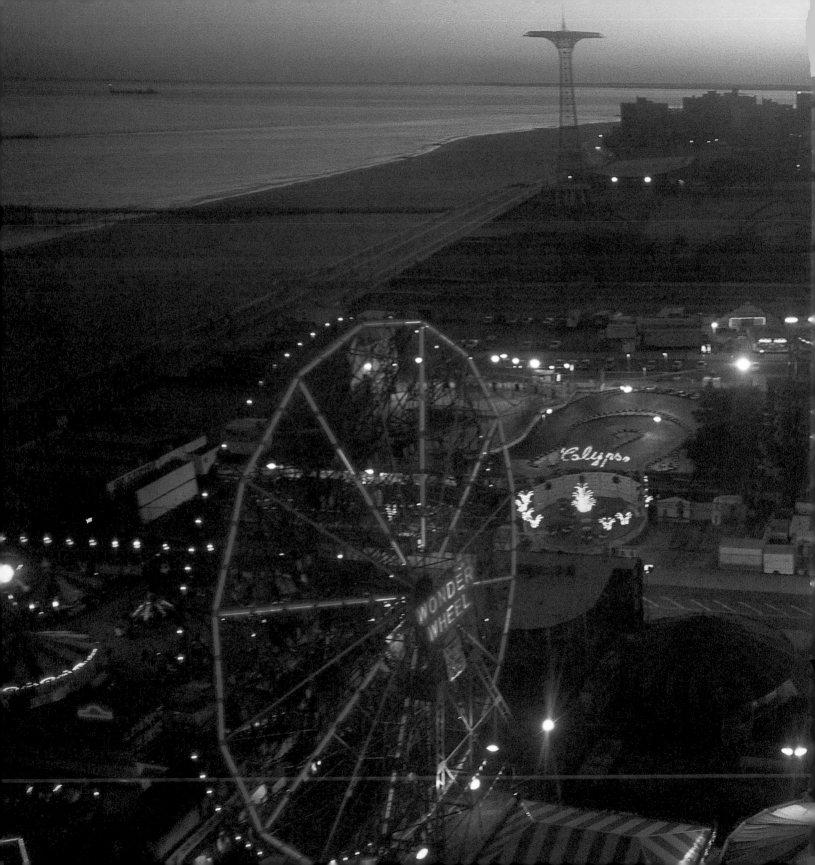

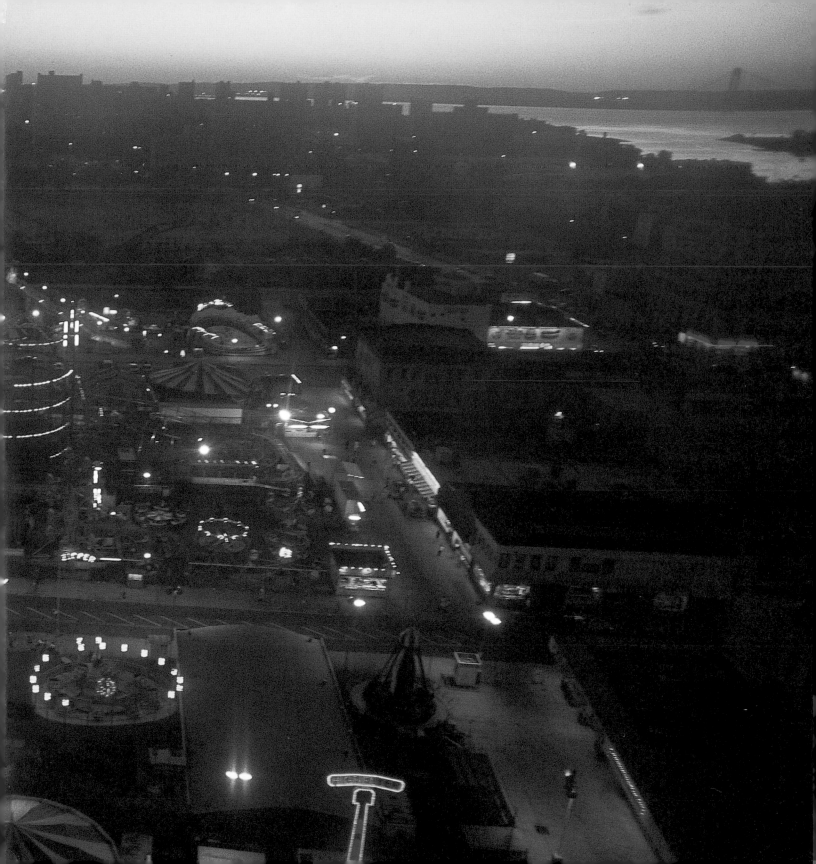

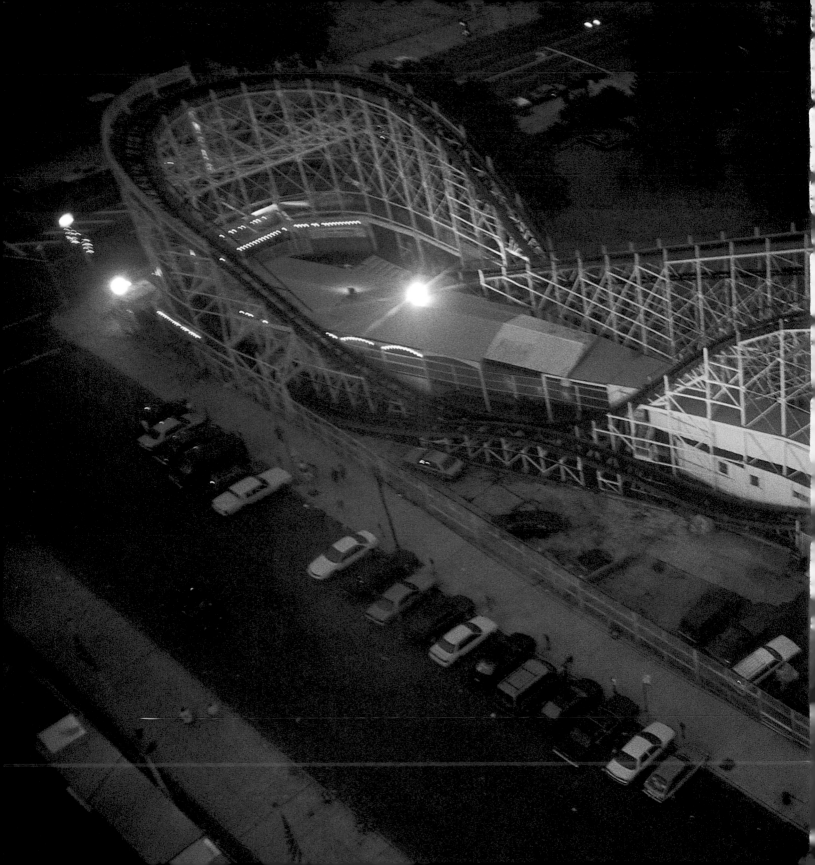

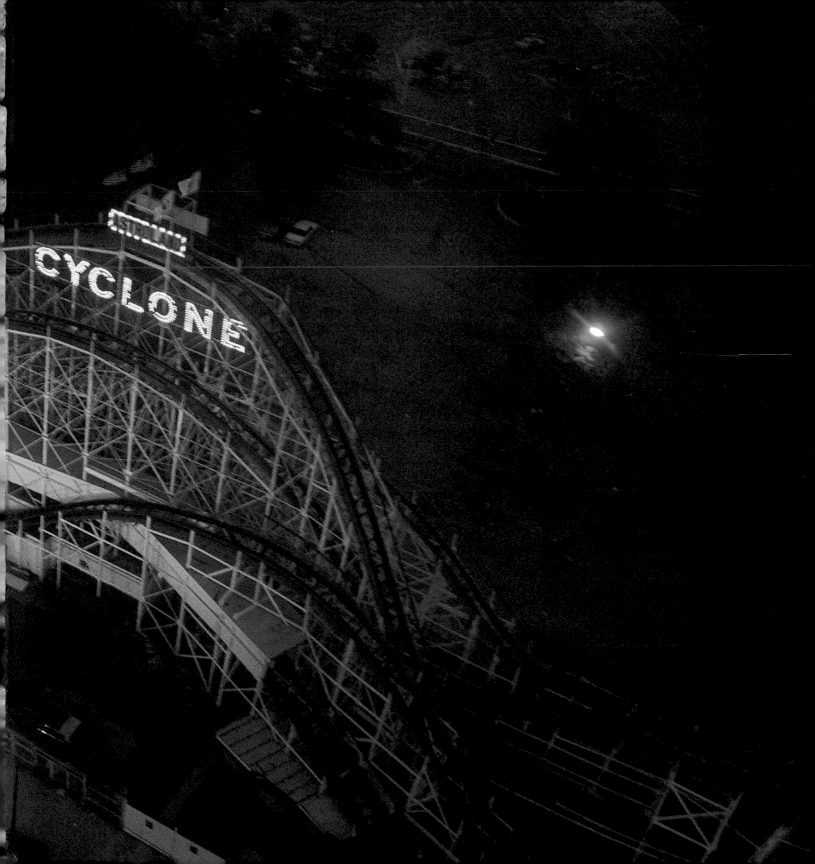

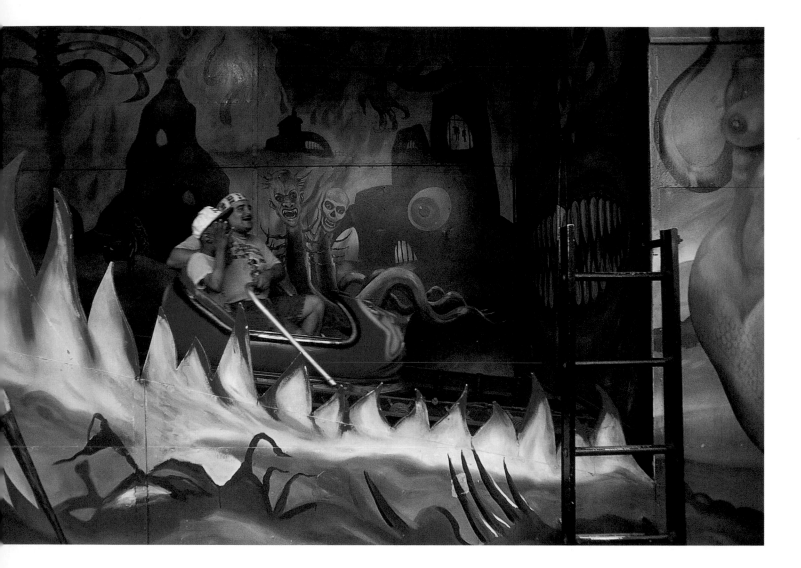

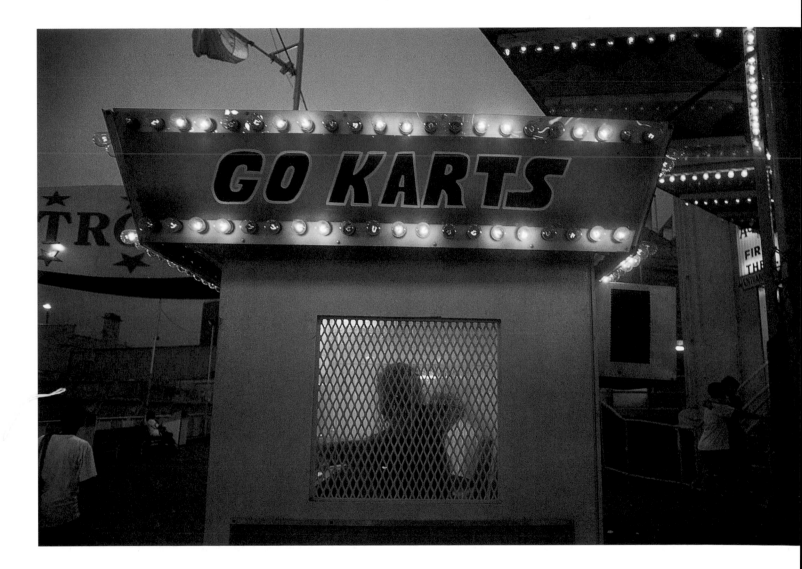

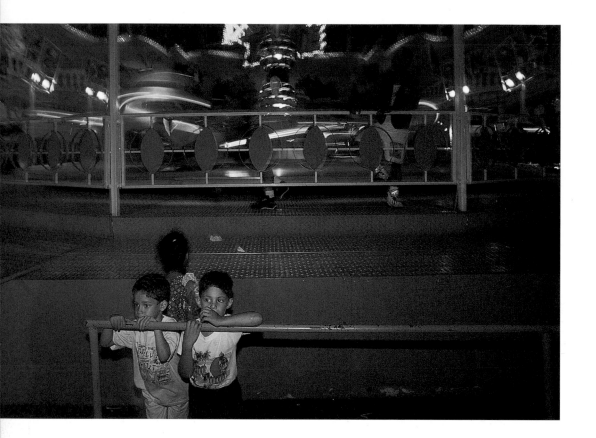

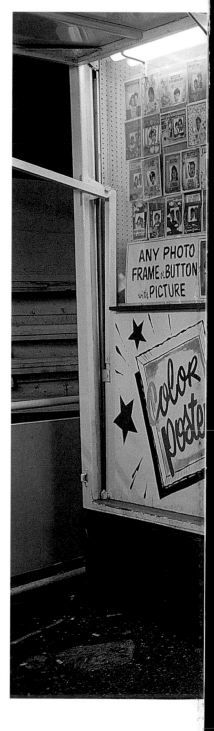

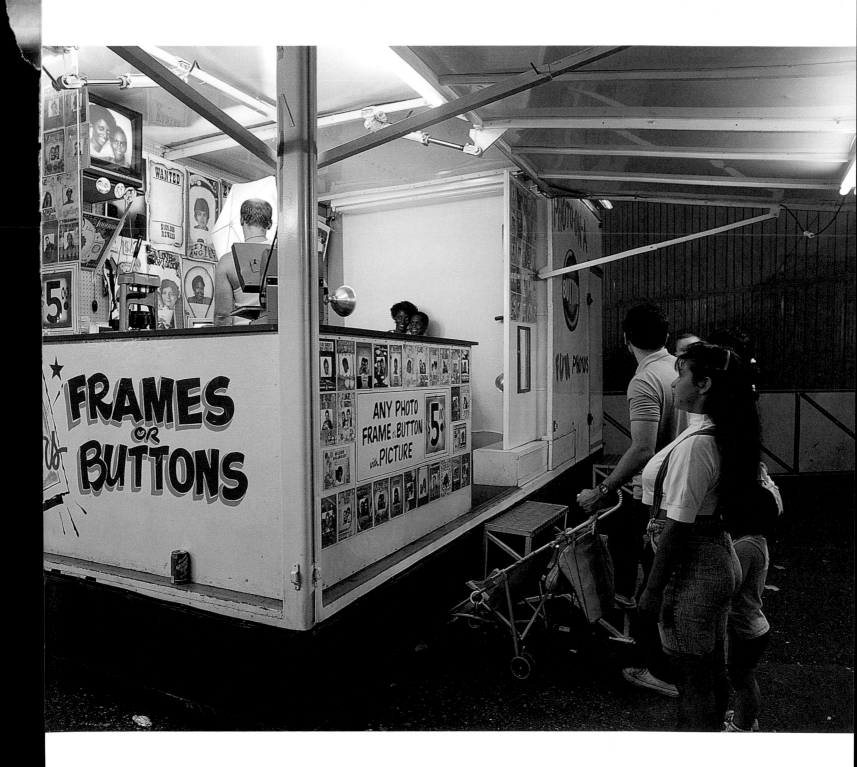

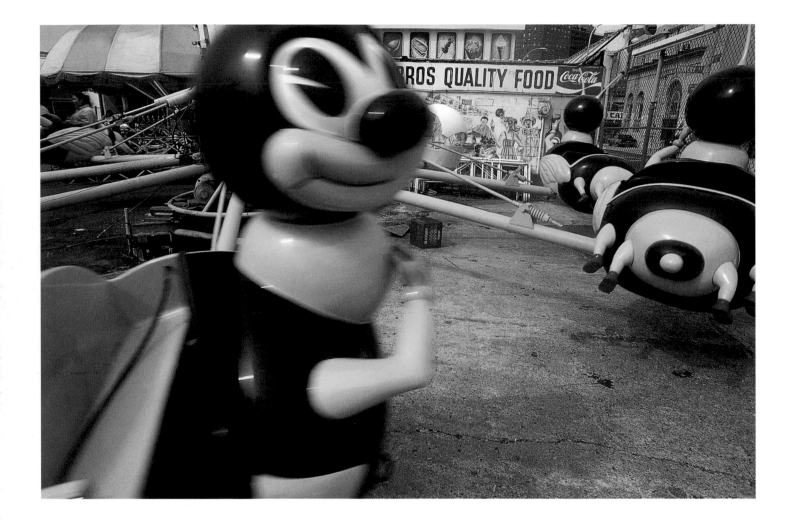

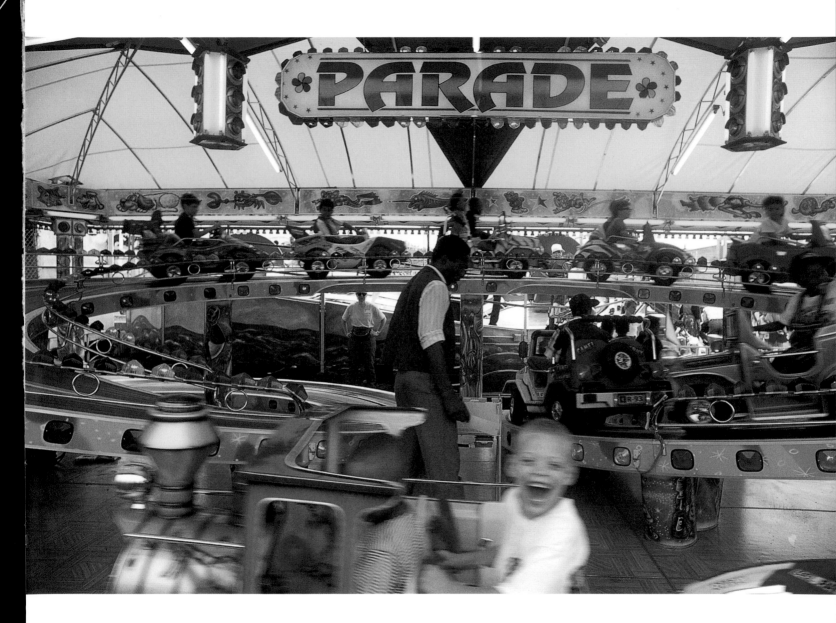

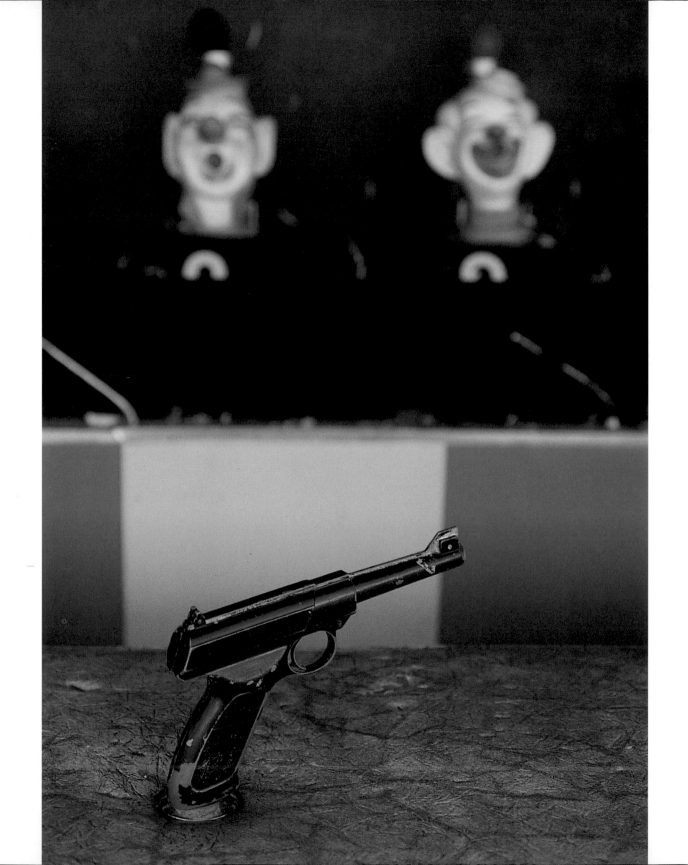

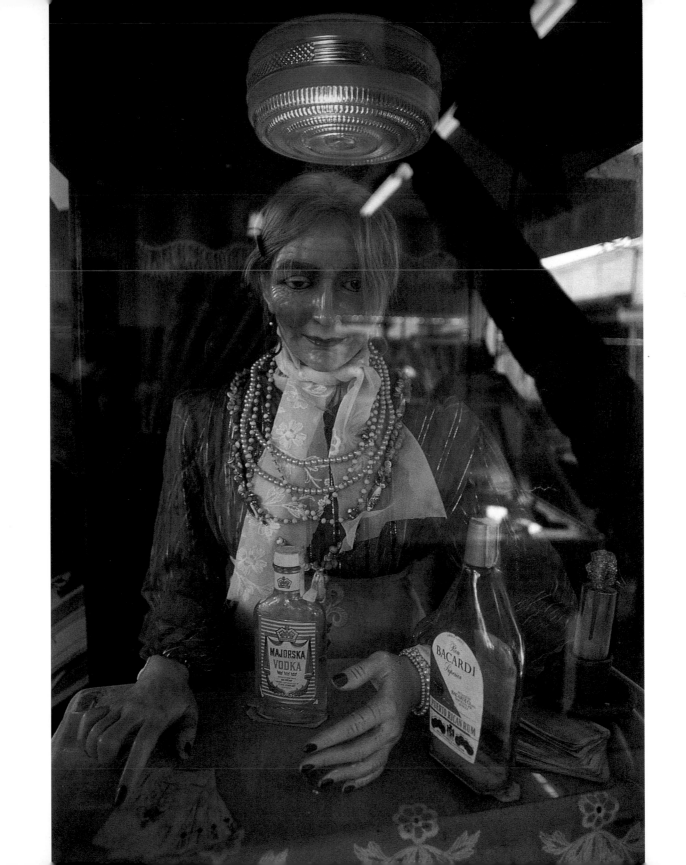

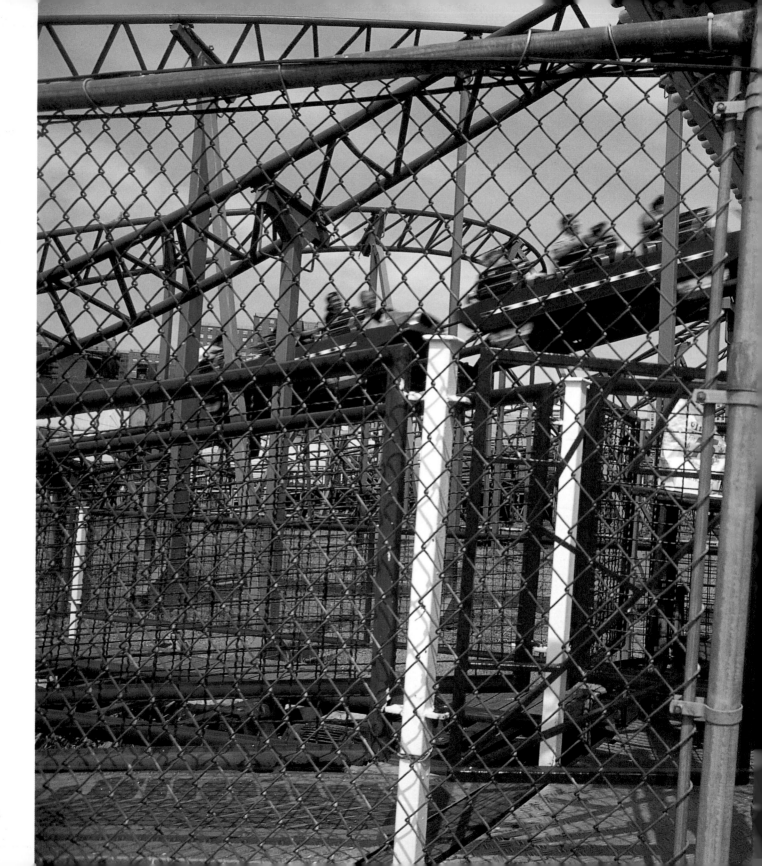

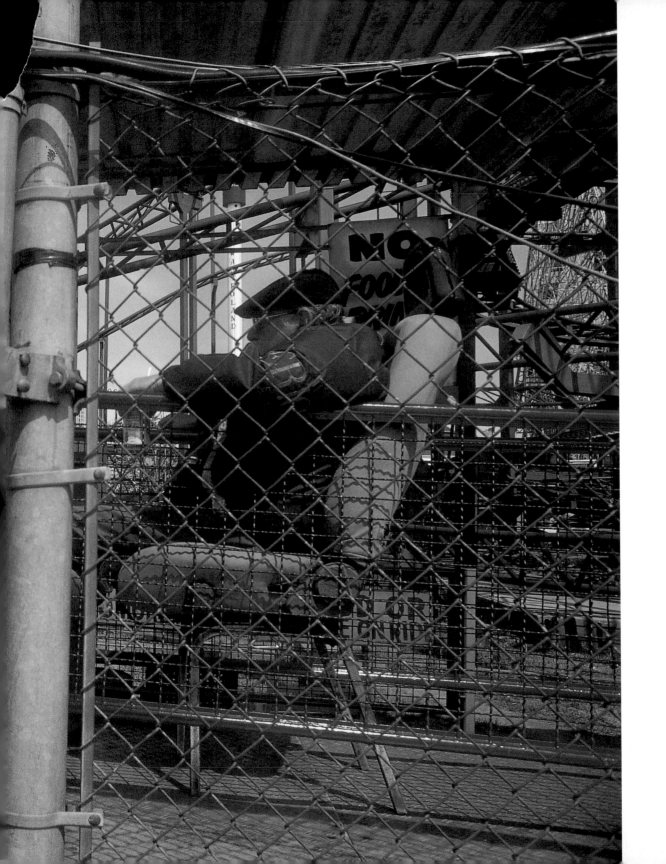

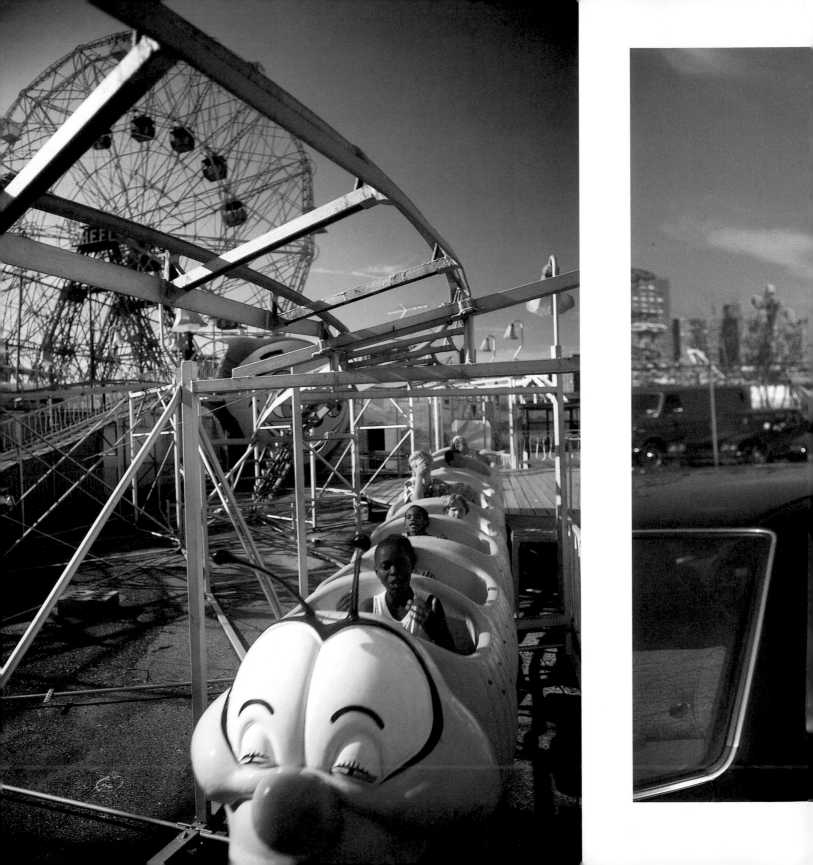

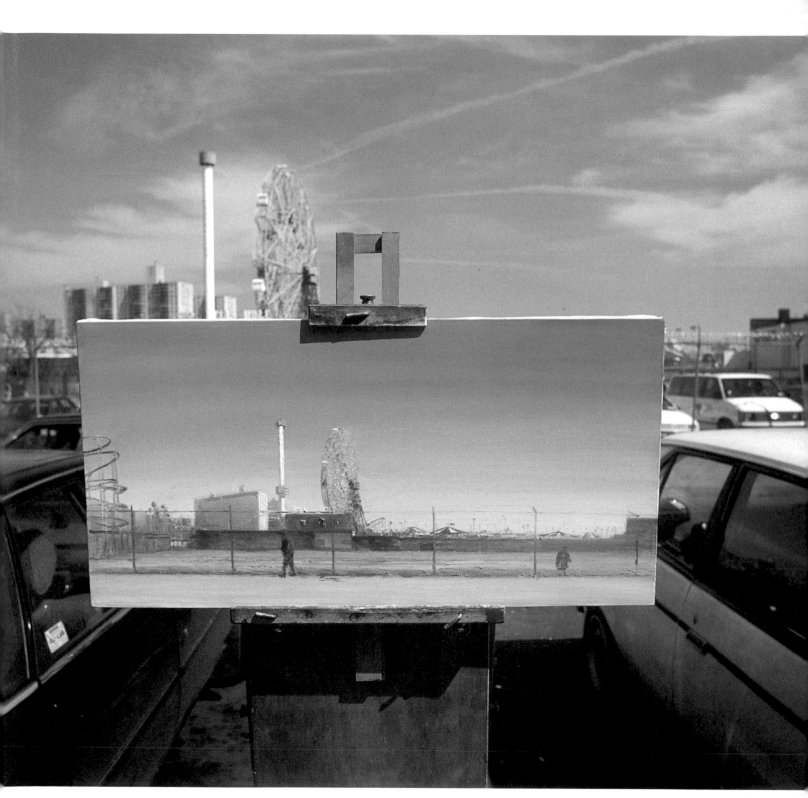

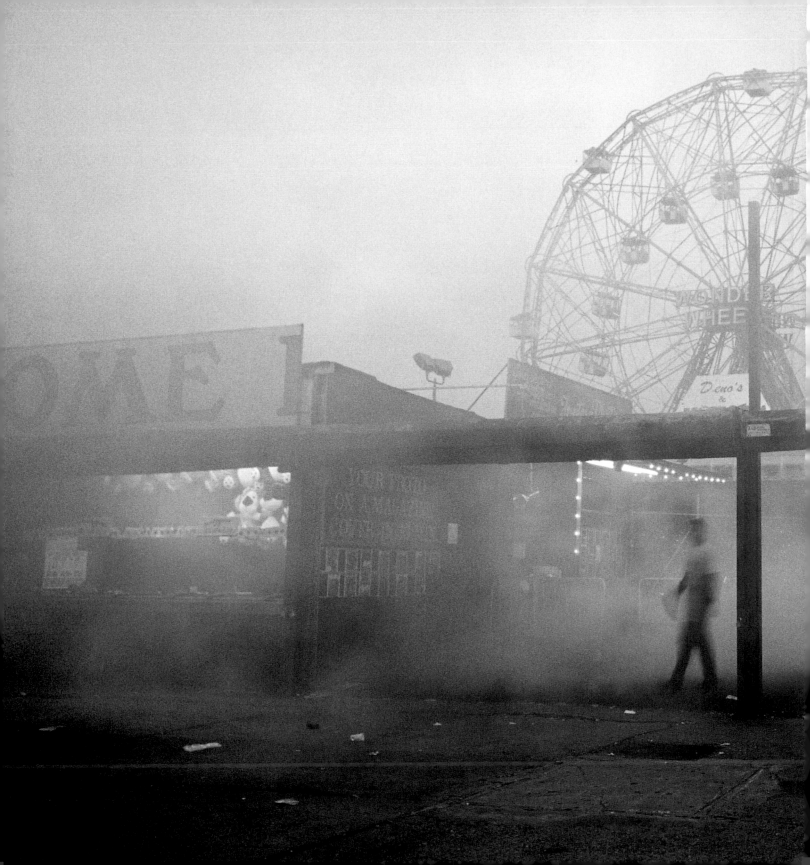

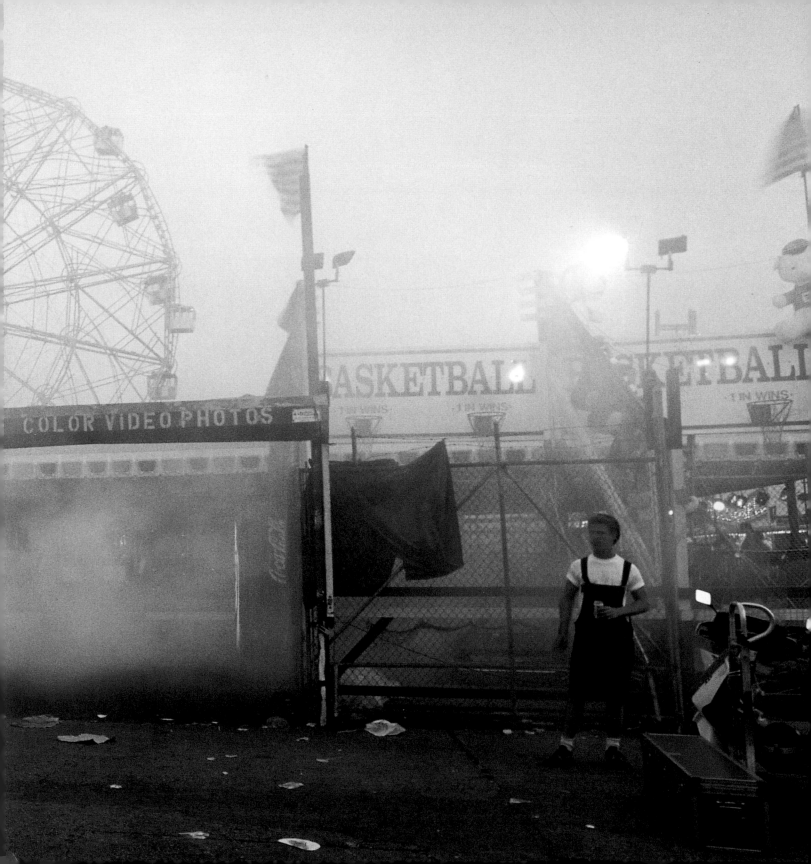

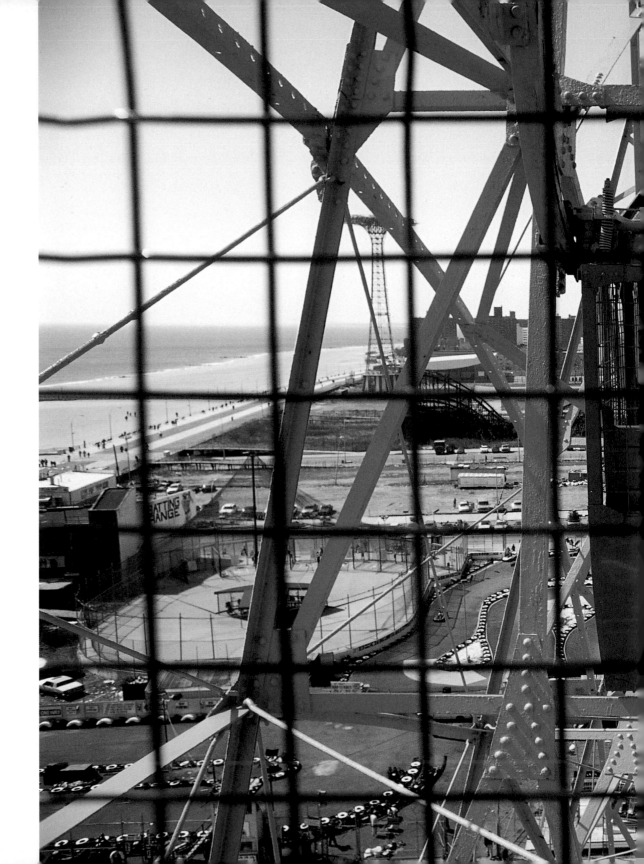

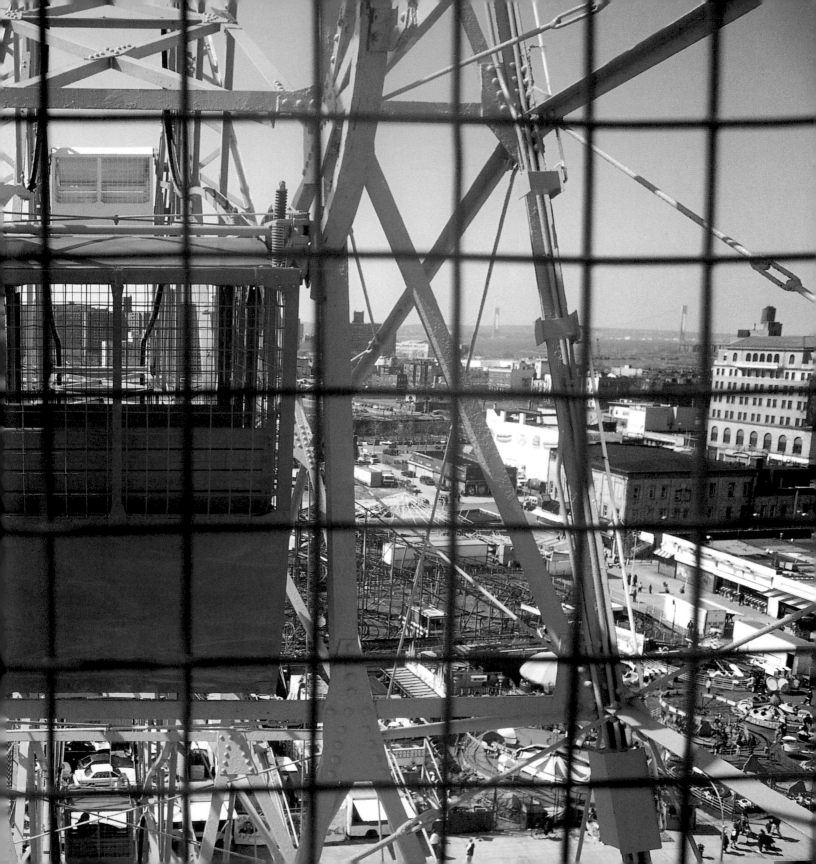

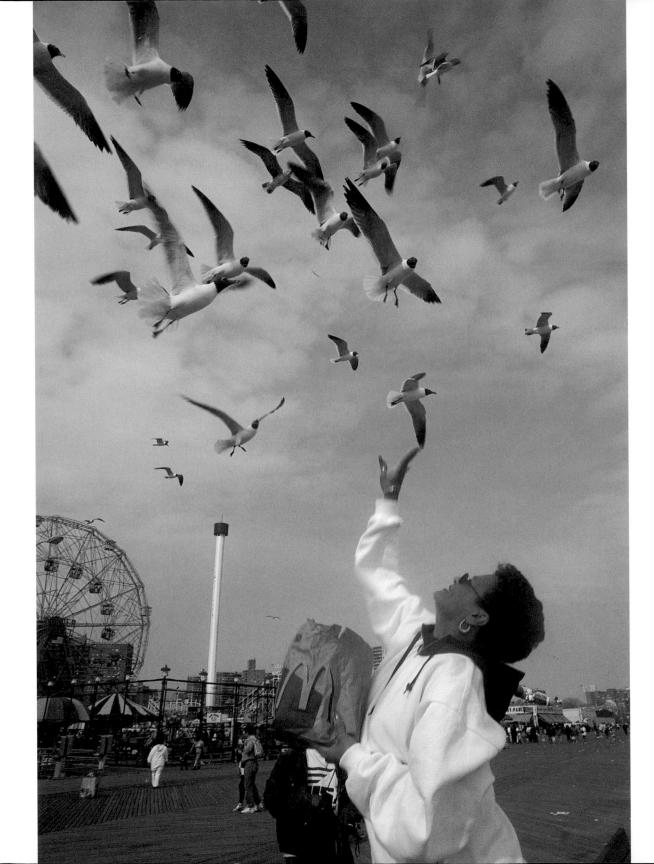

The Boardwalk

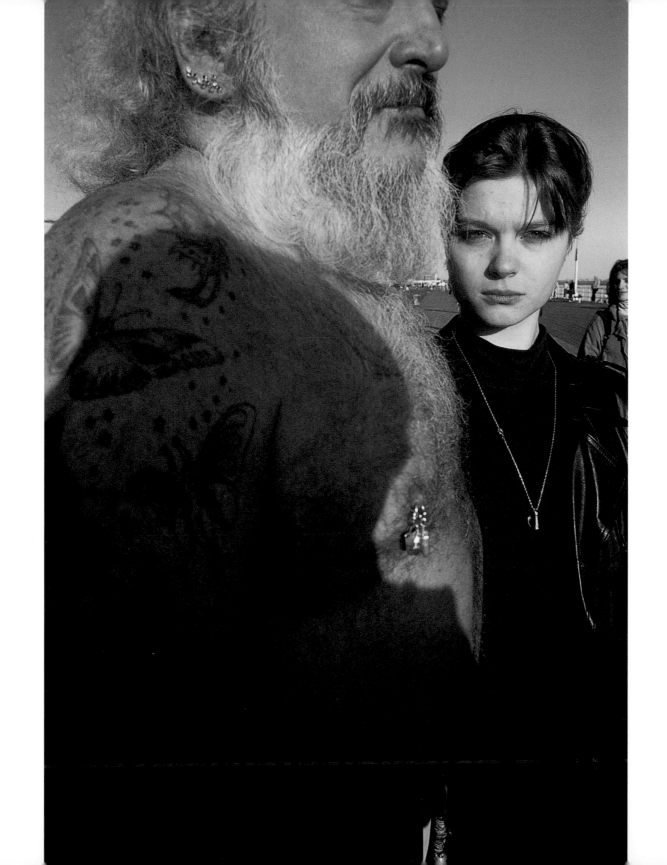

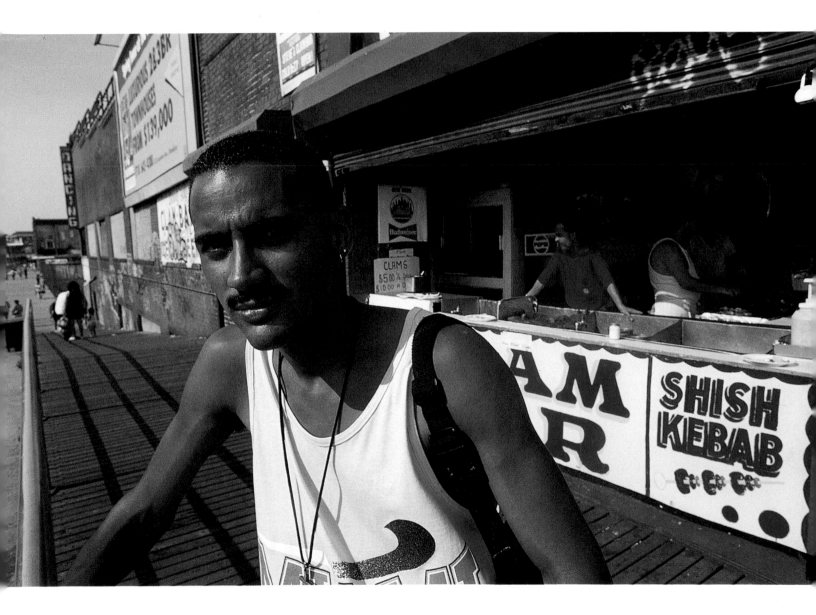

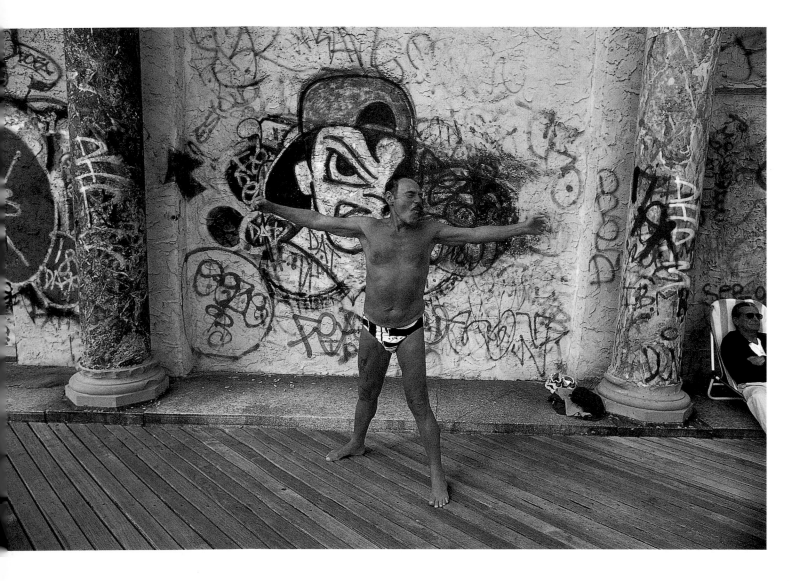

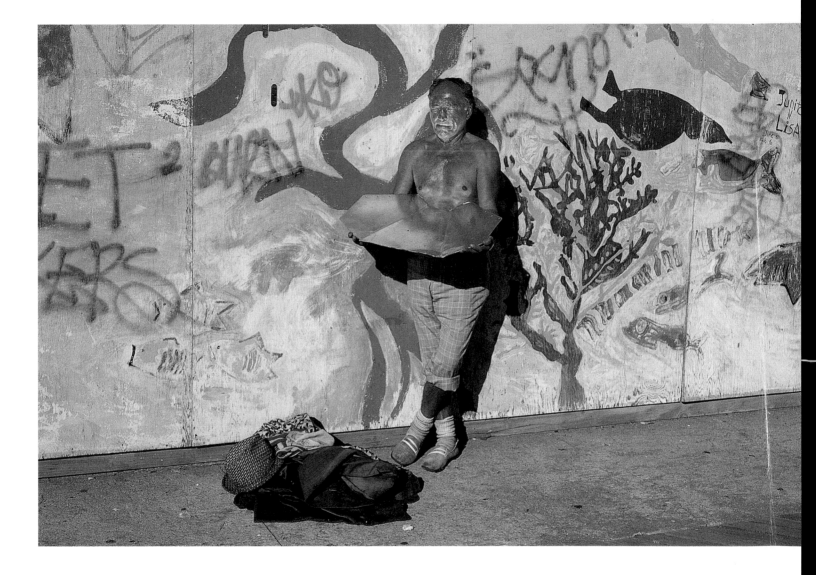

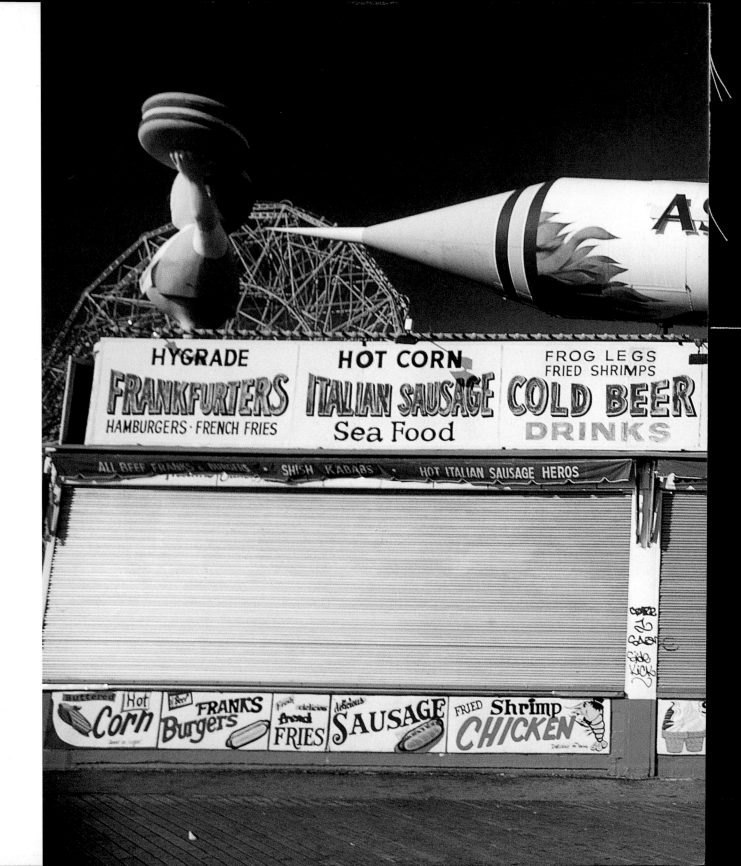

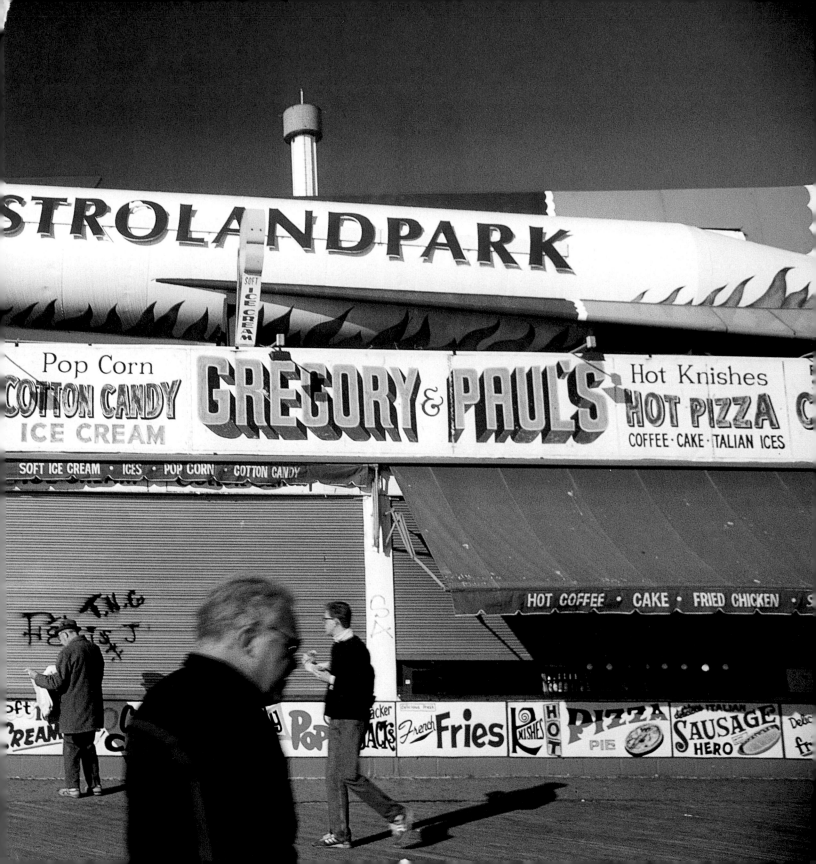

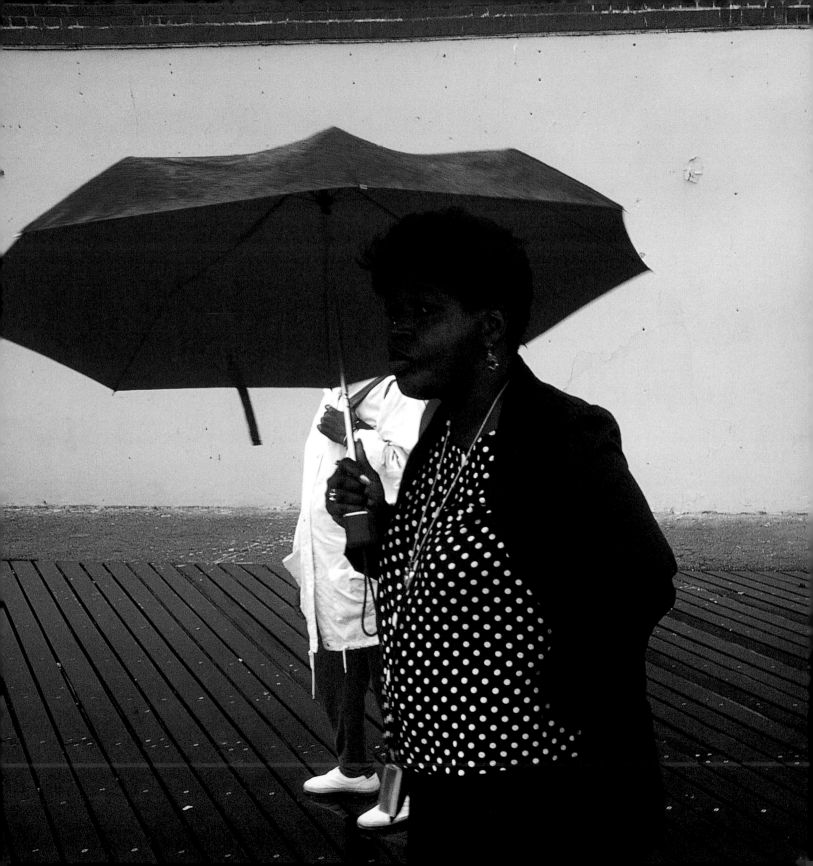

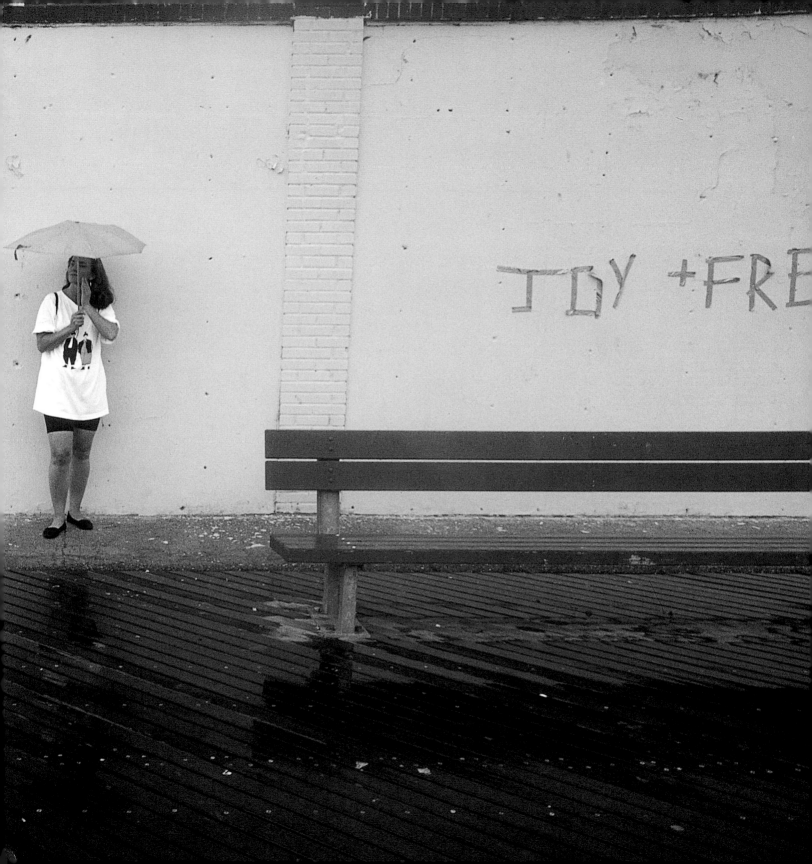

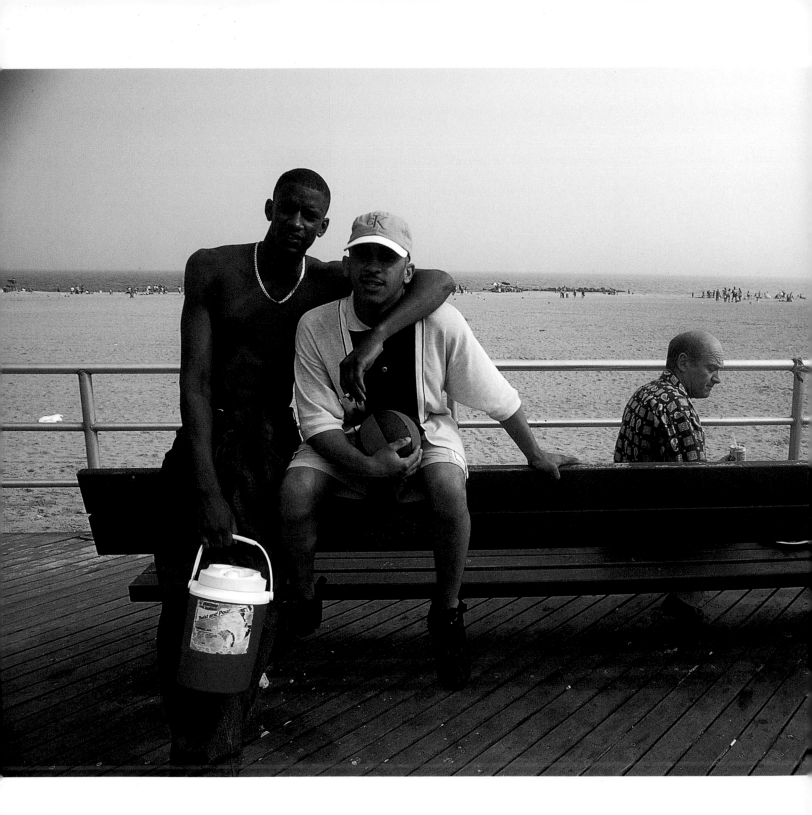

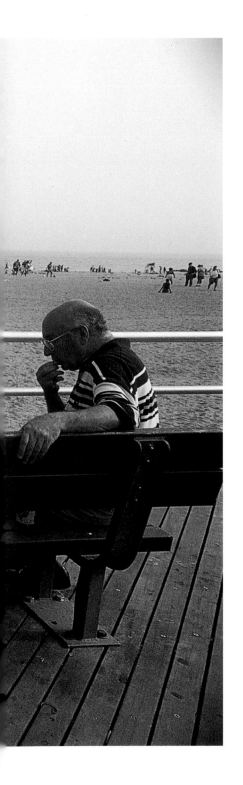

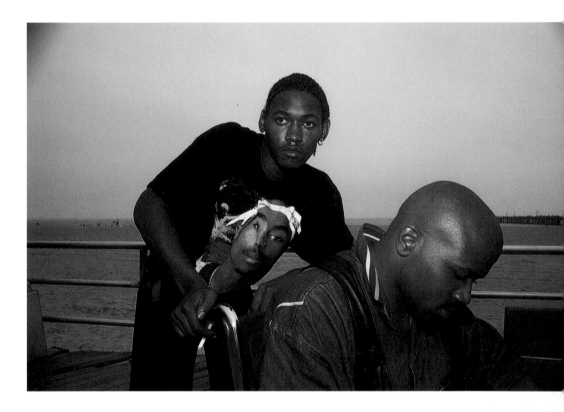

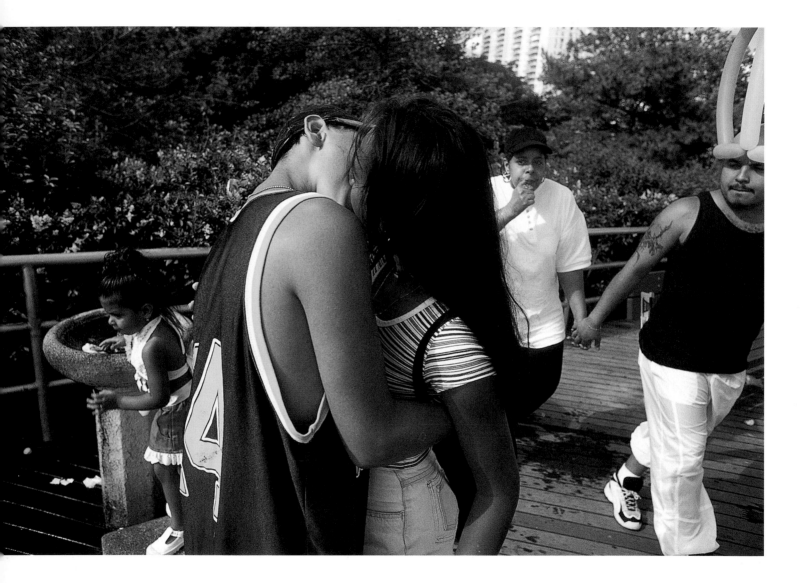

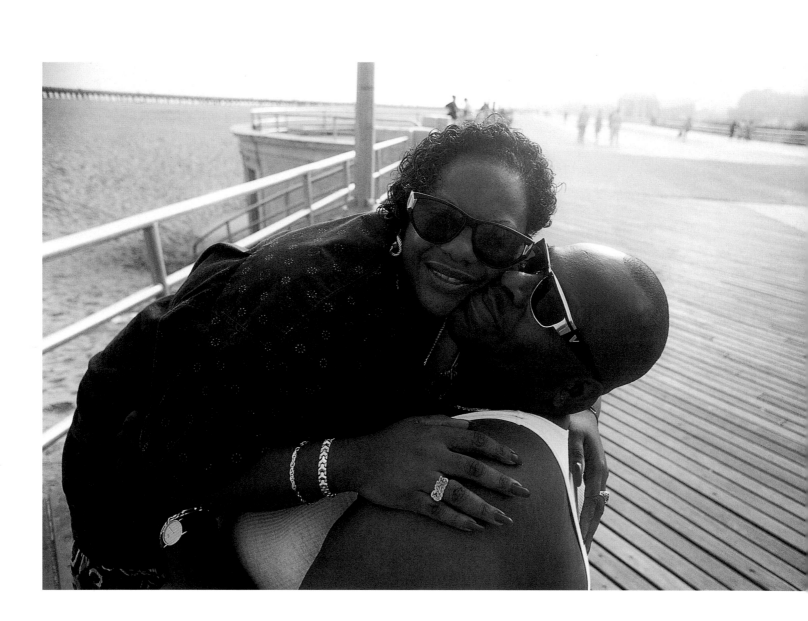

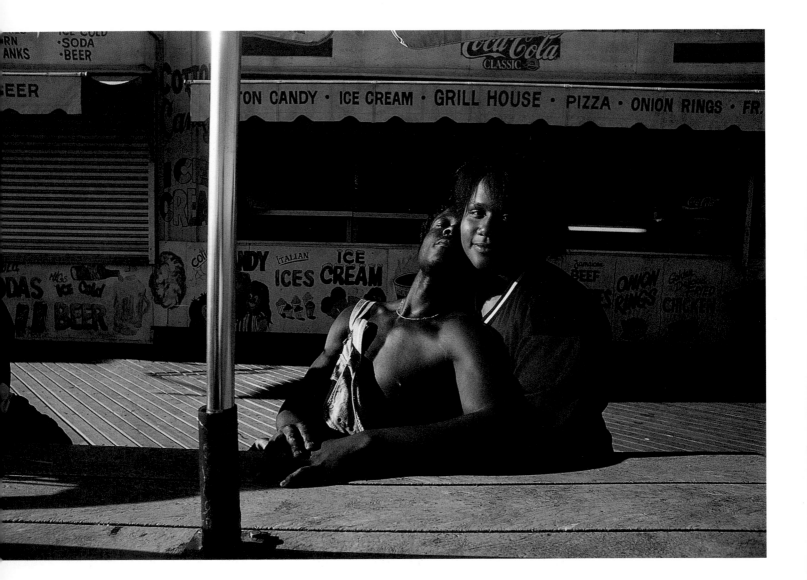

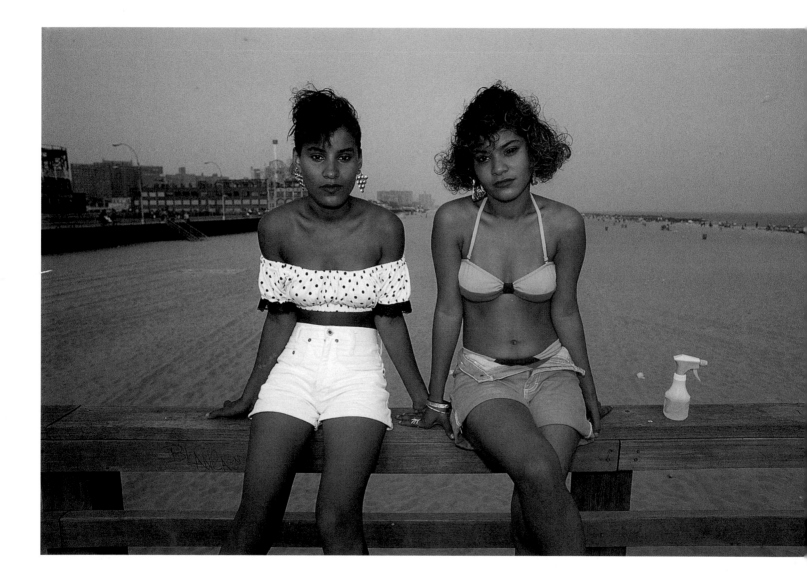

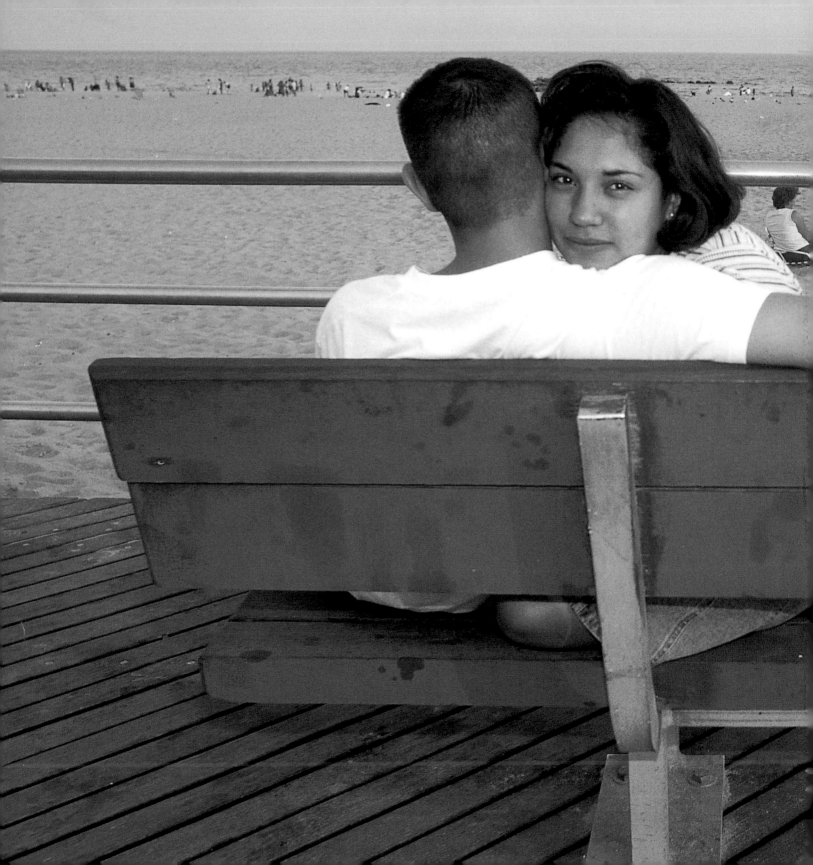

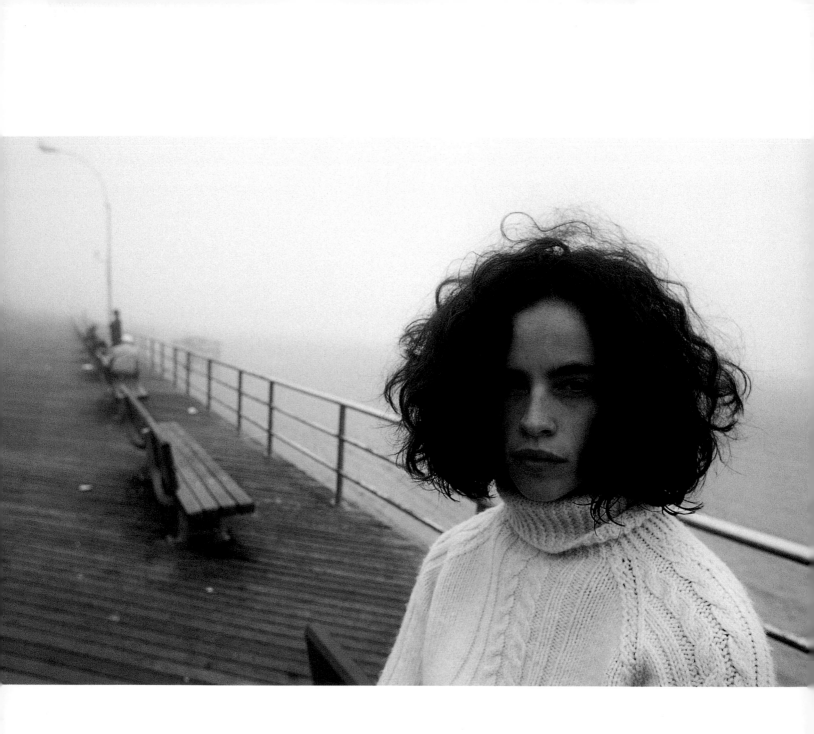

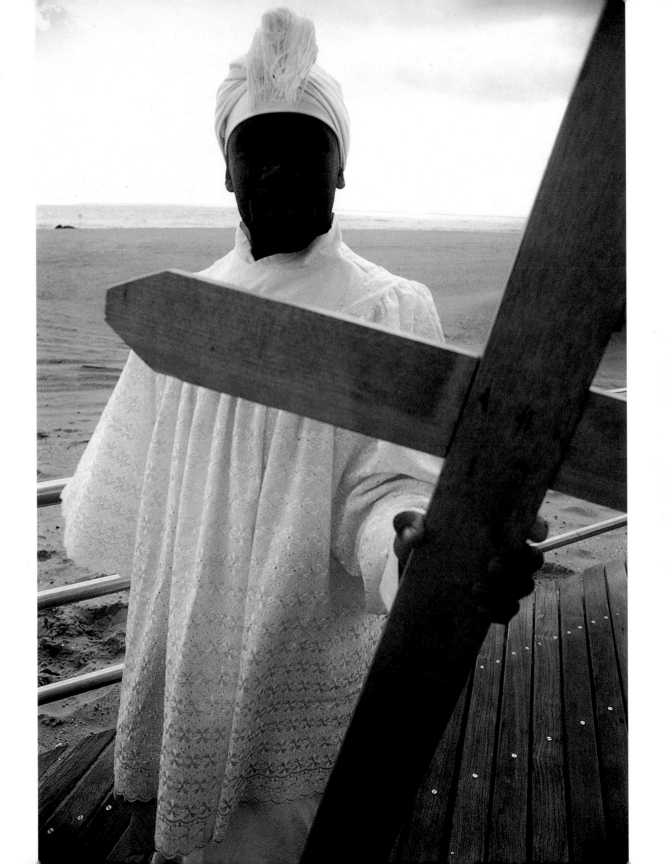

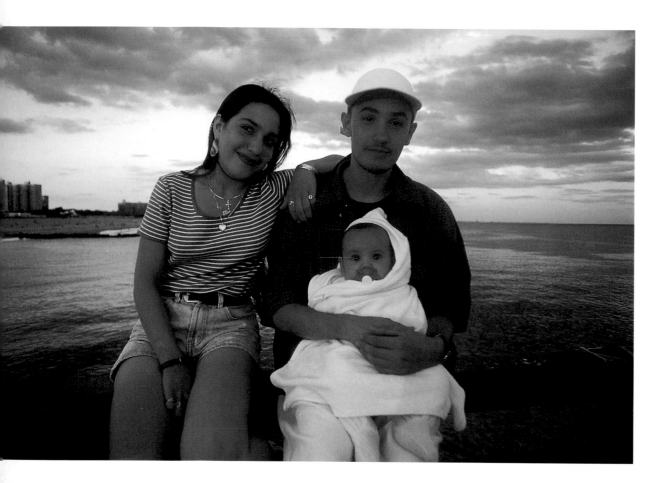

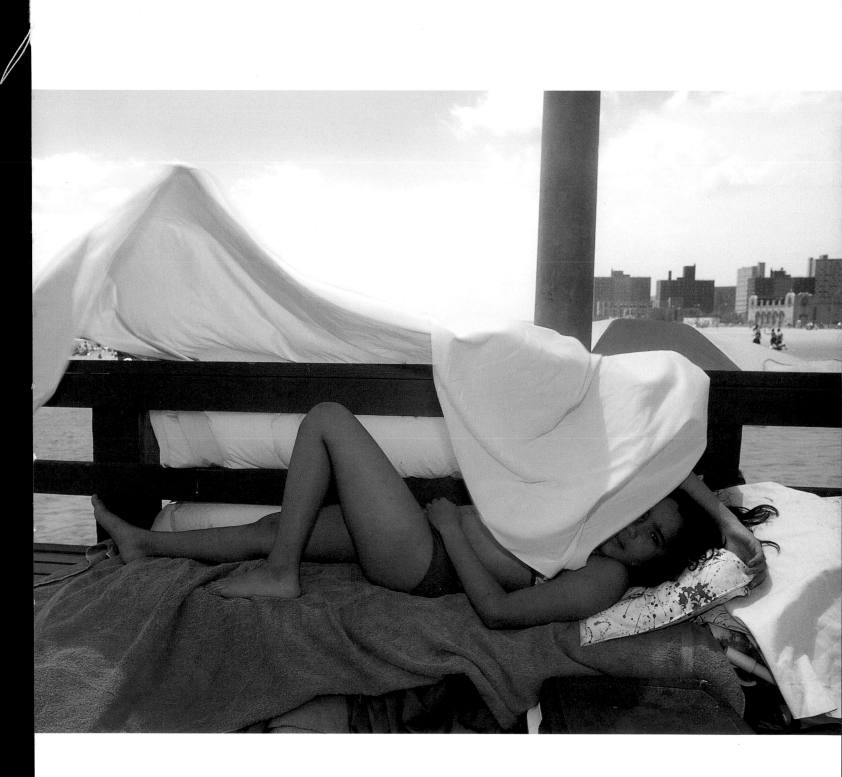

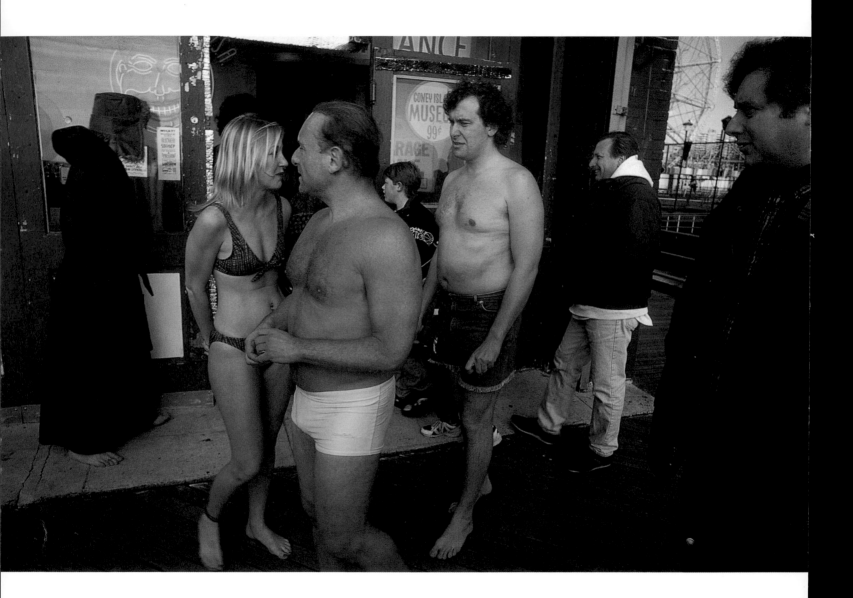

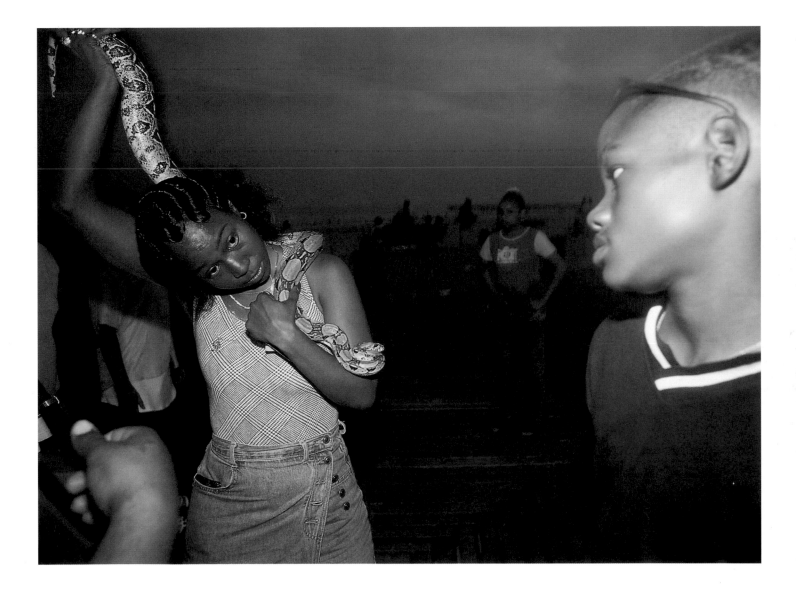

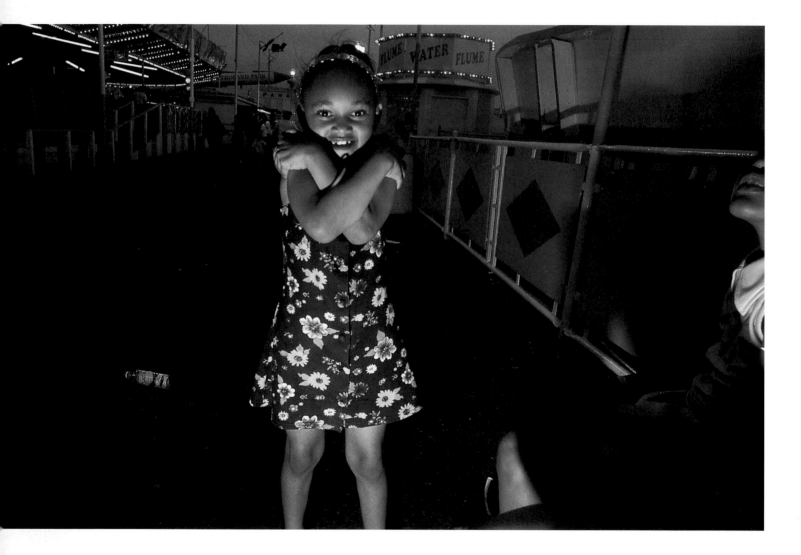

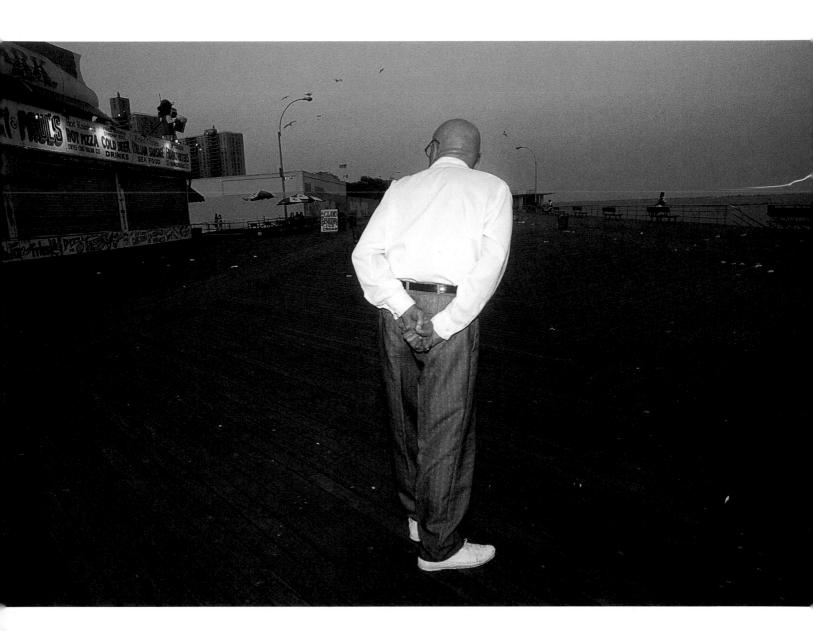

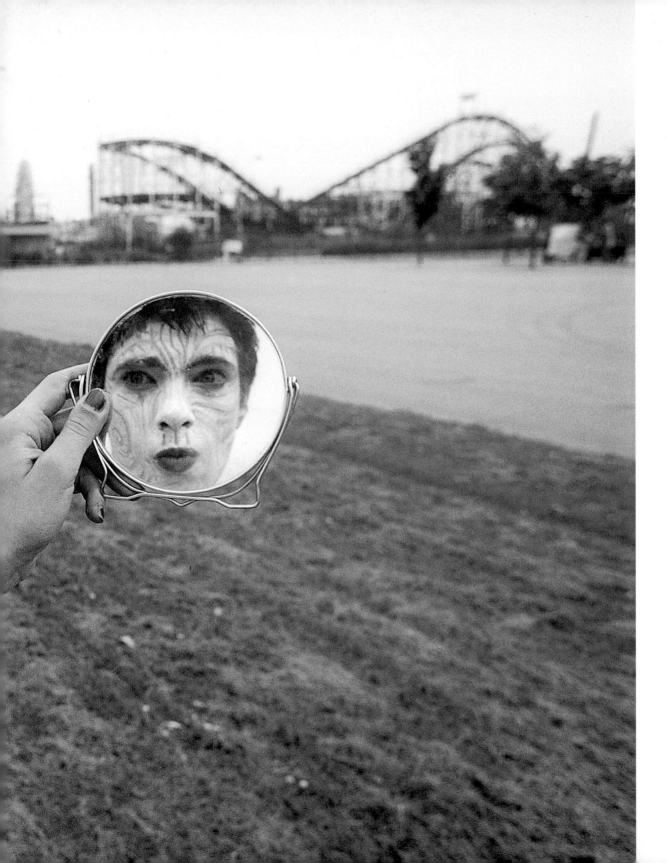

Mermaid Parade

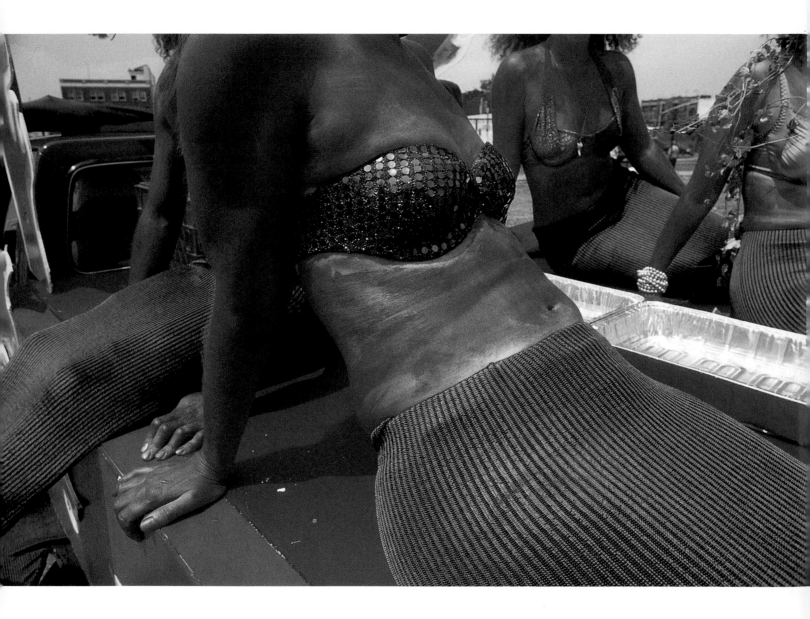

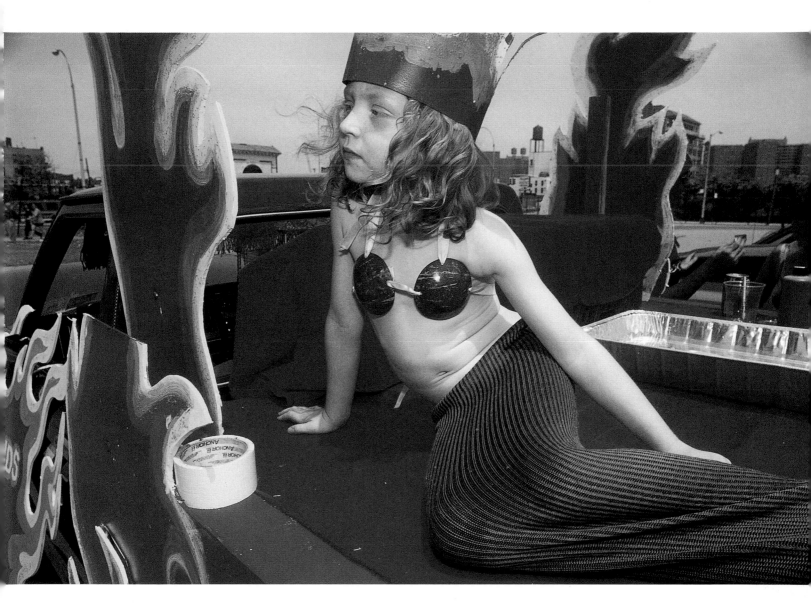

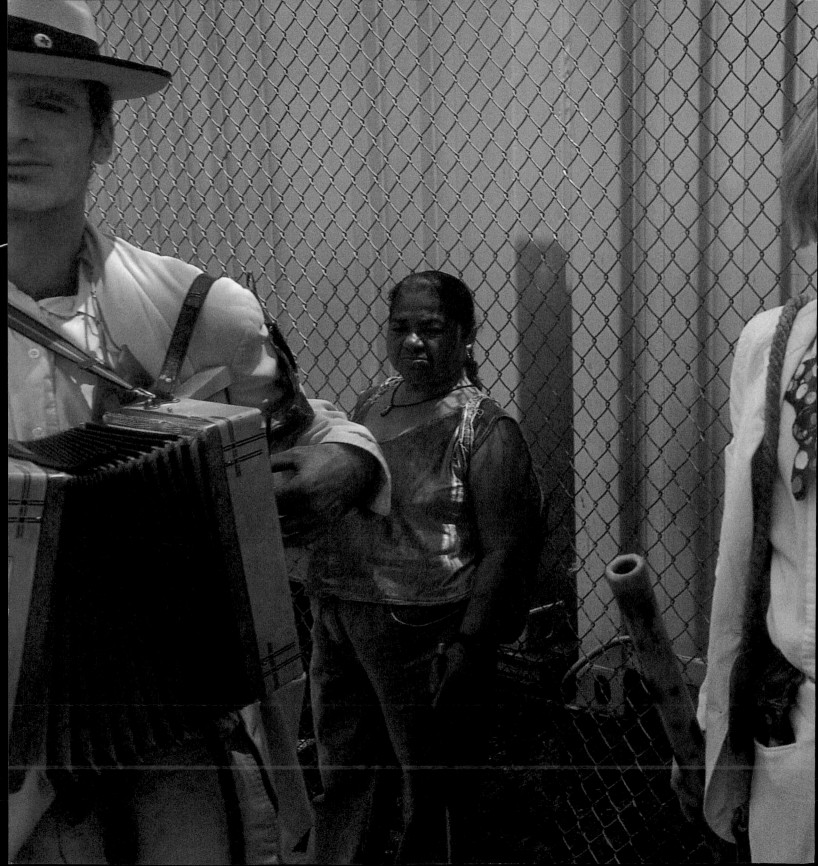

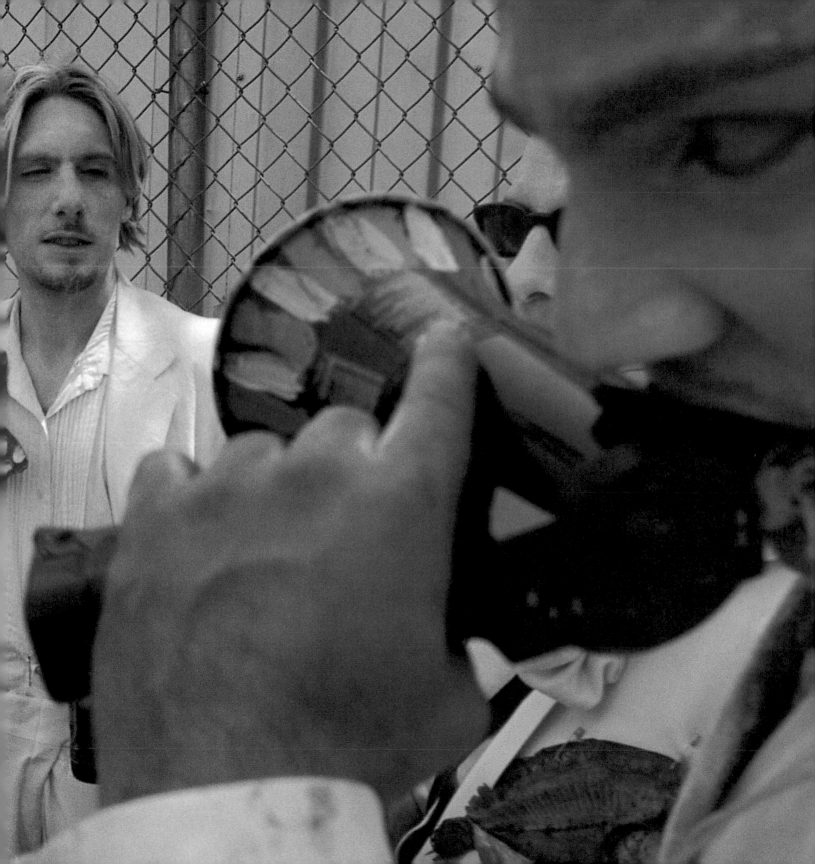

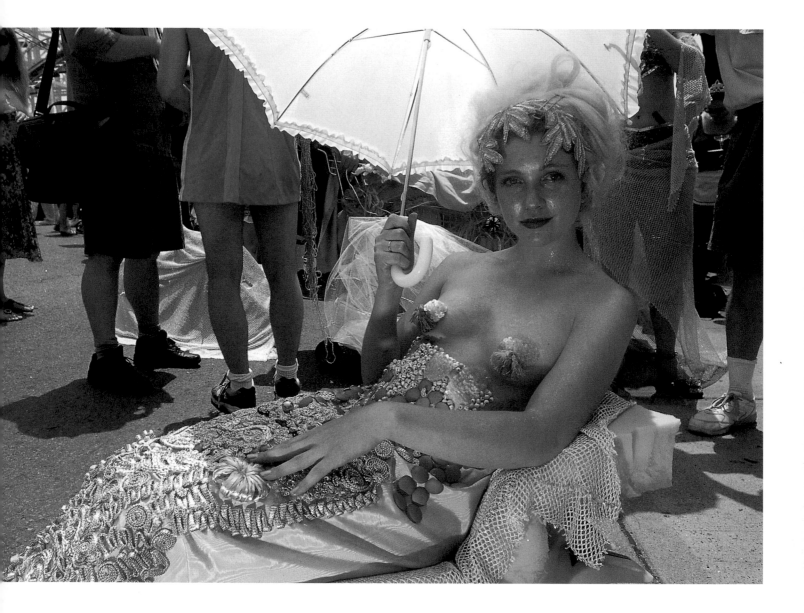

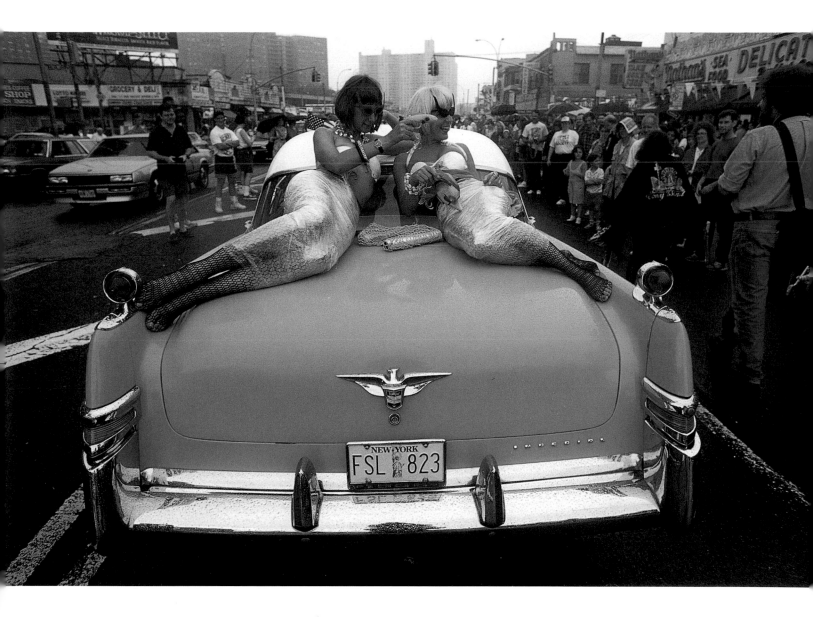

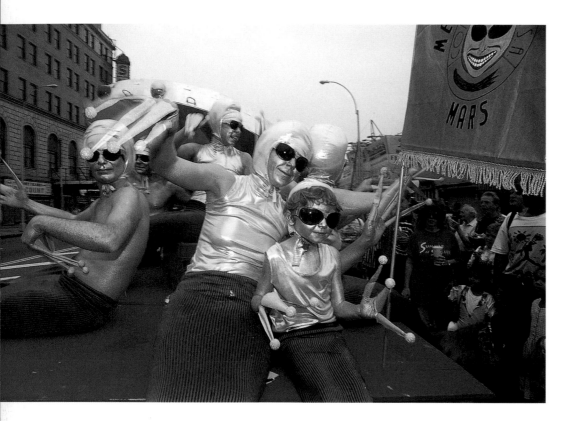

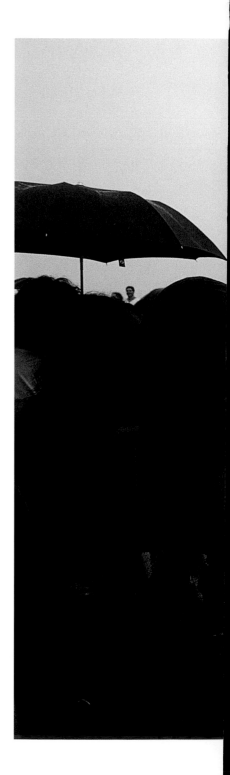

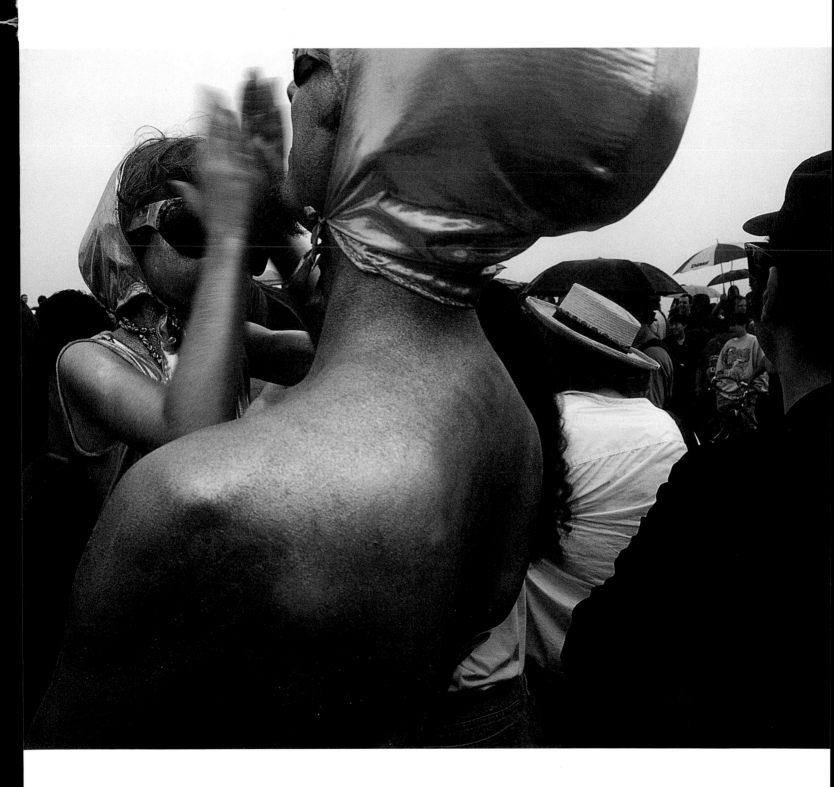

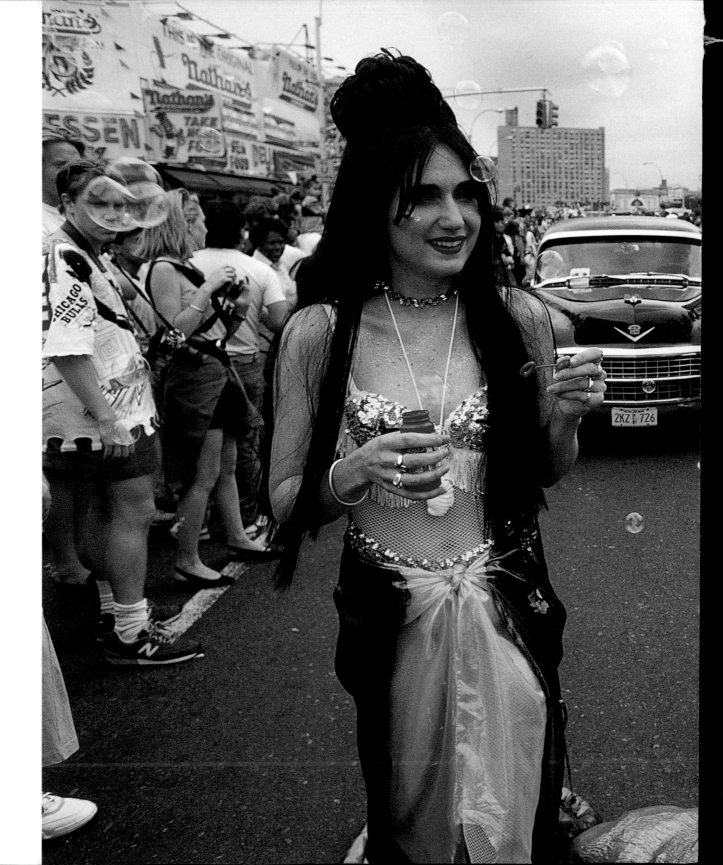

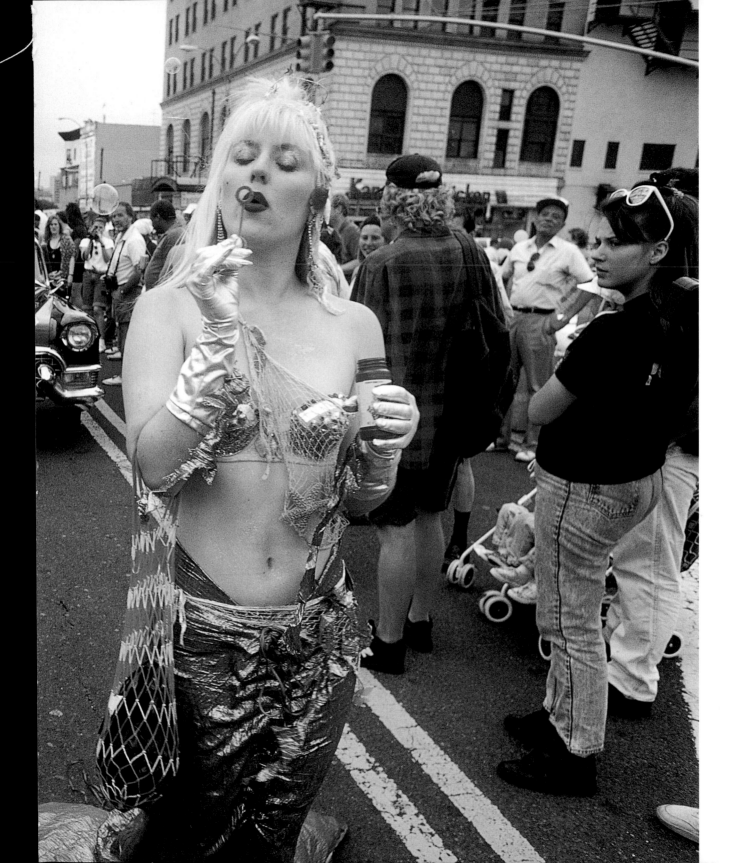

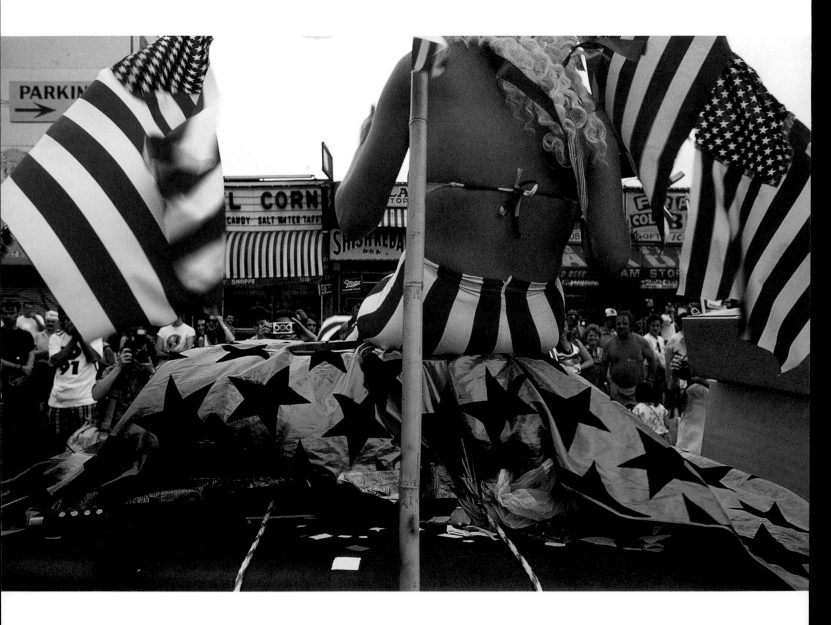

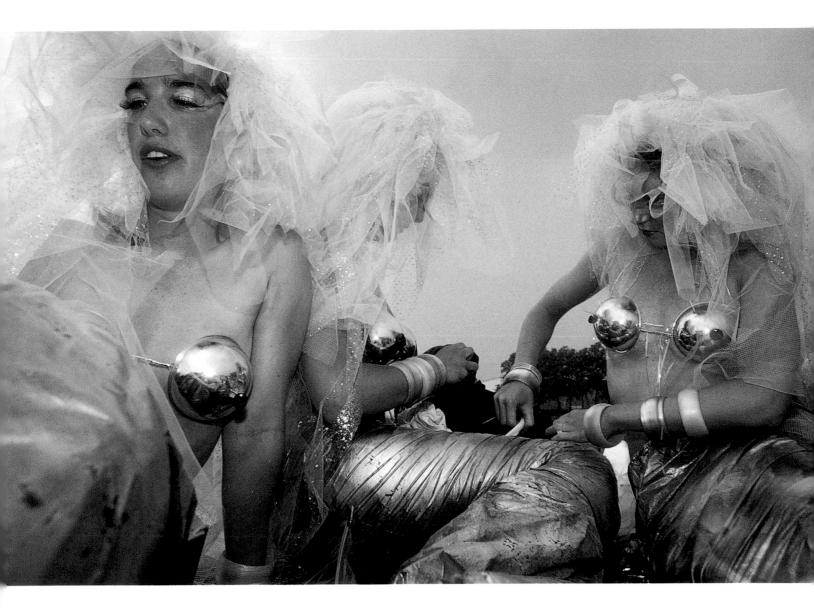

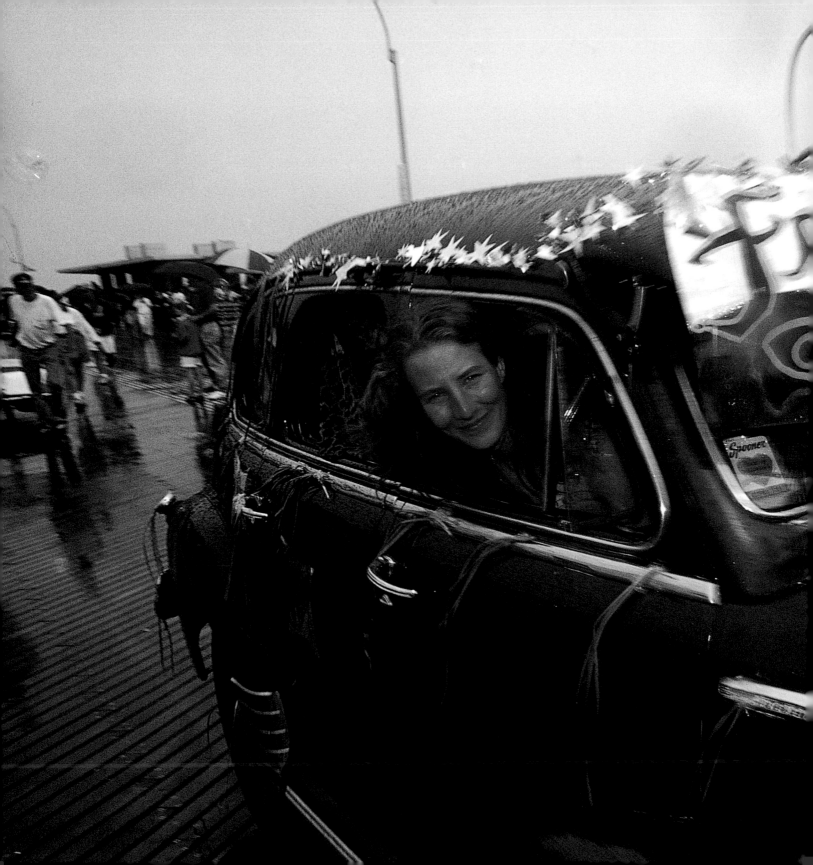

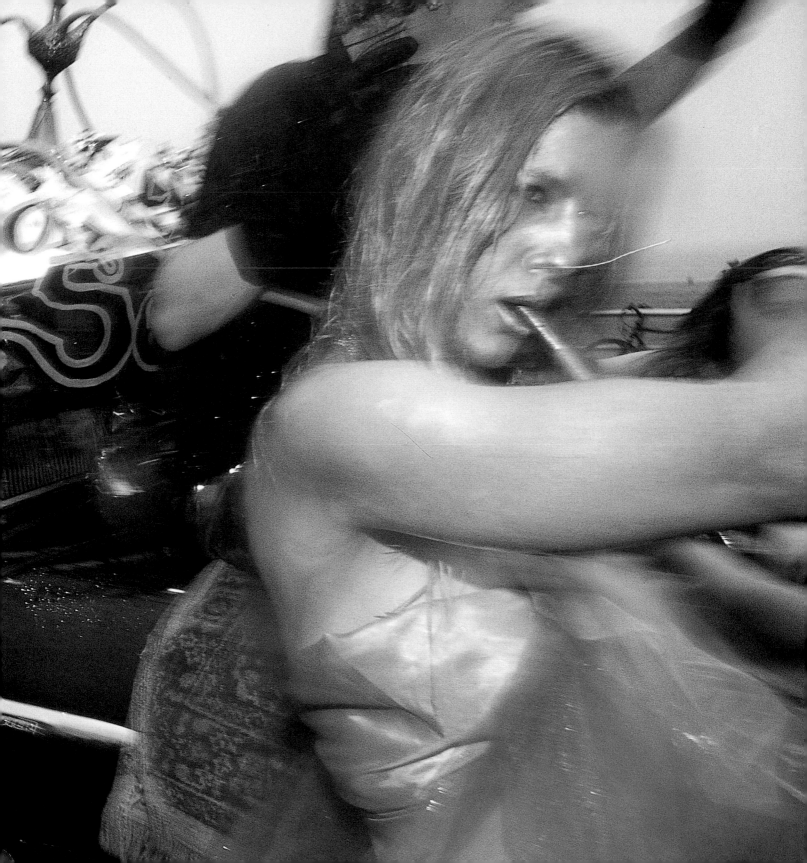

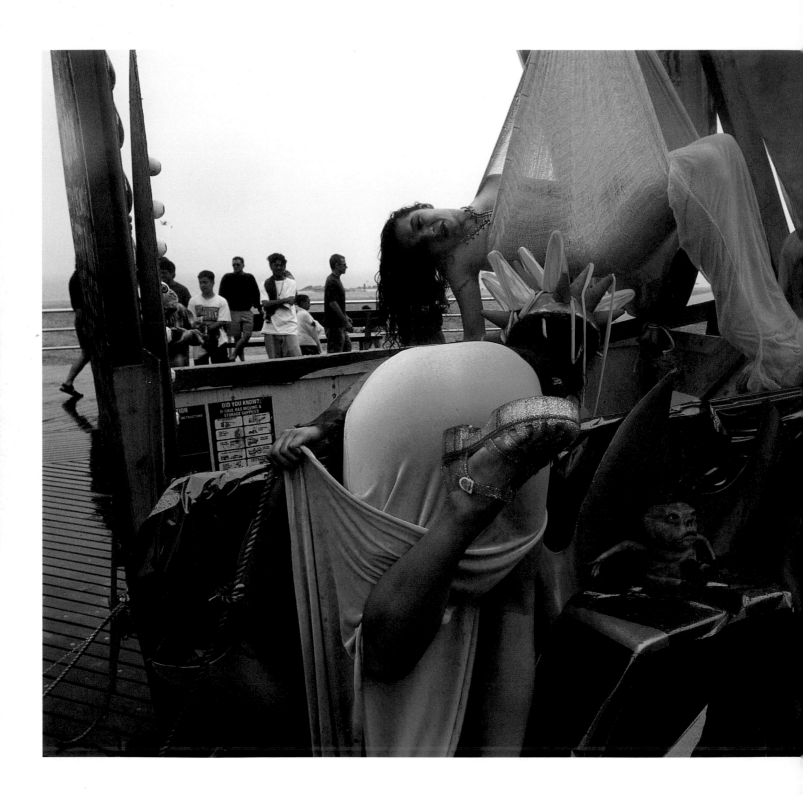

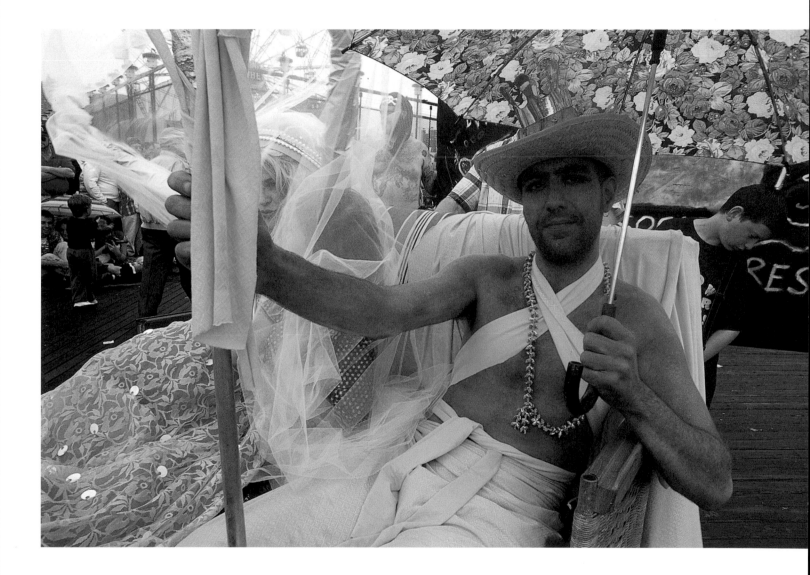

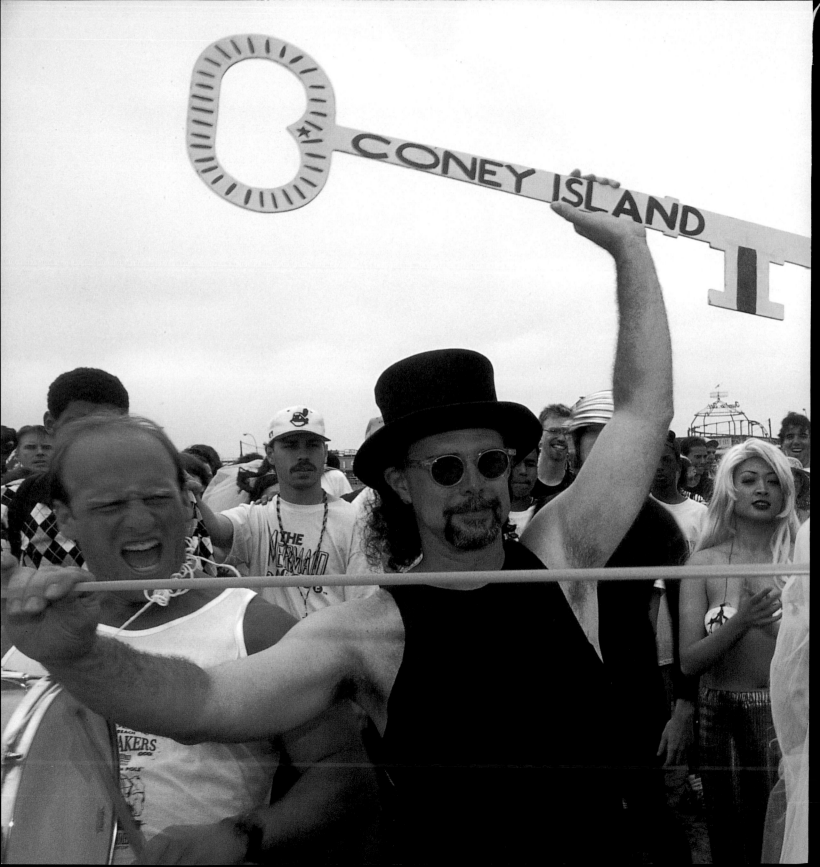

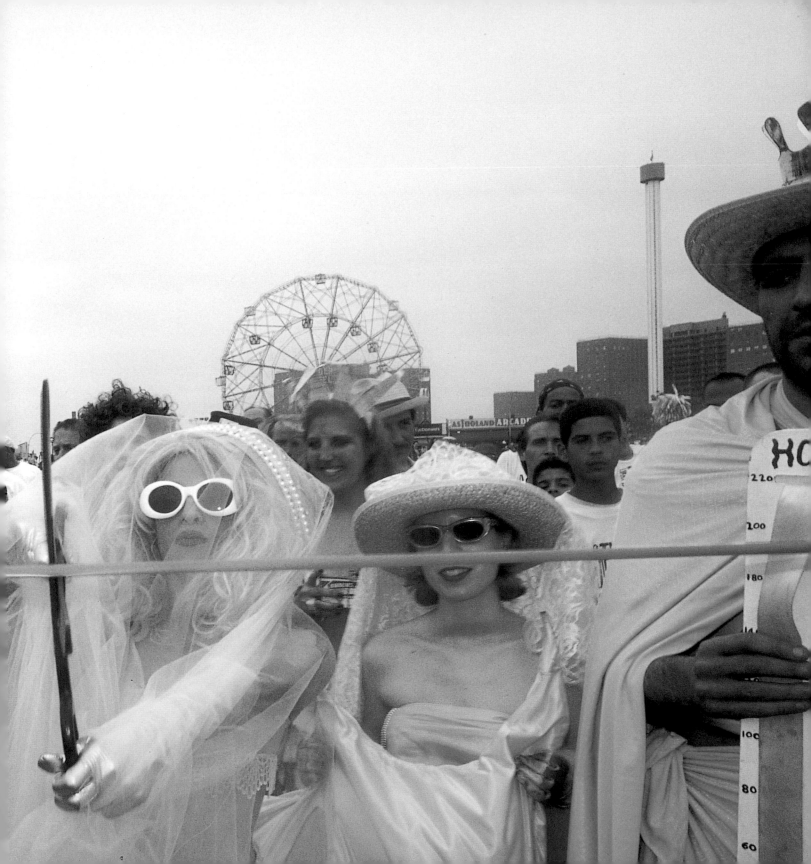

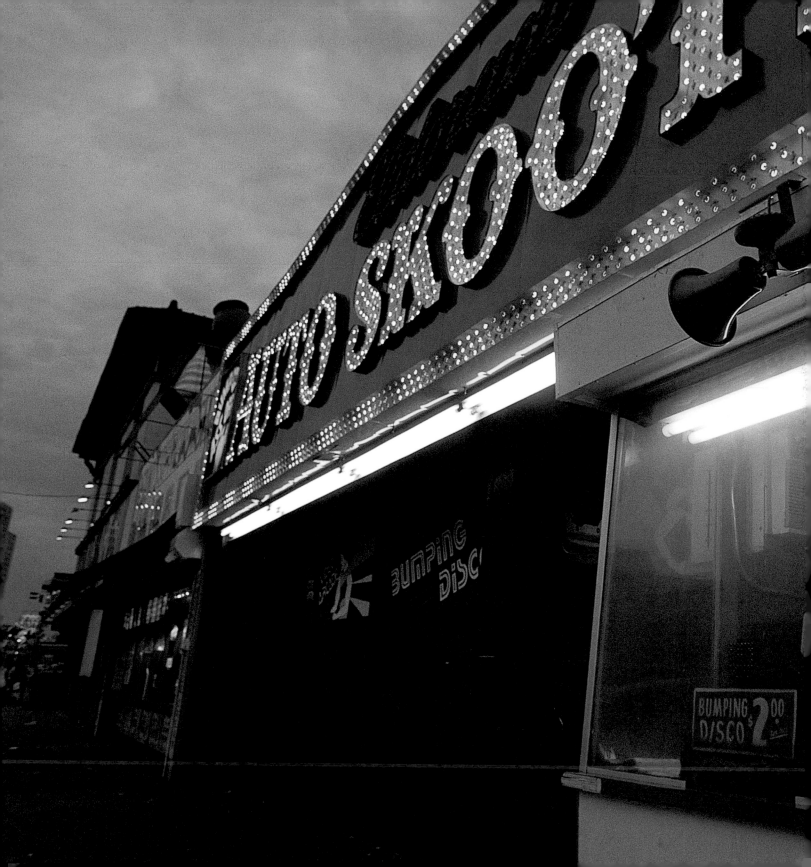

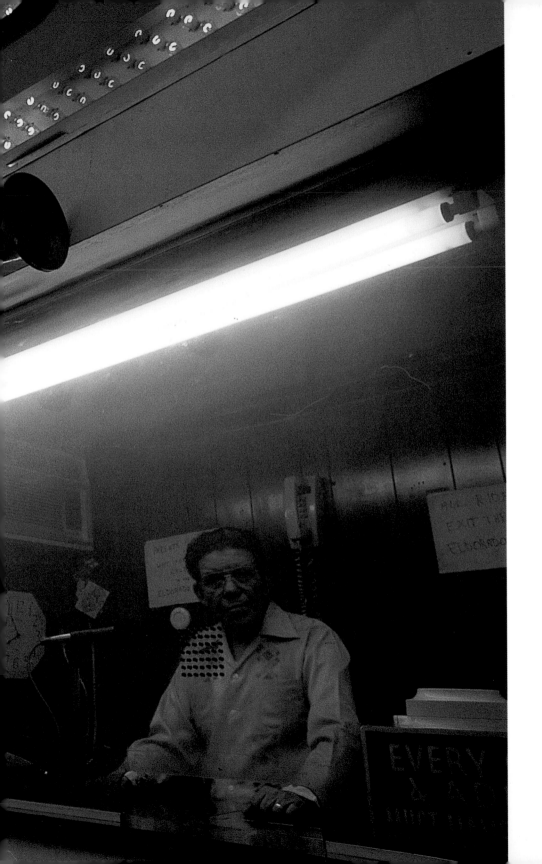

The Workers

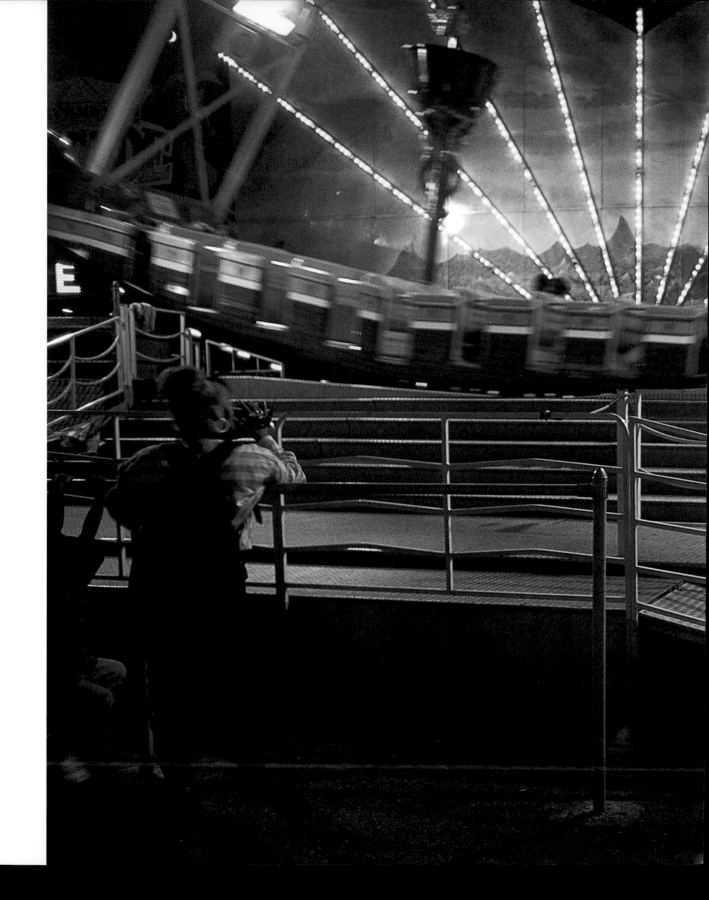

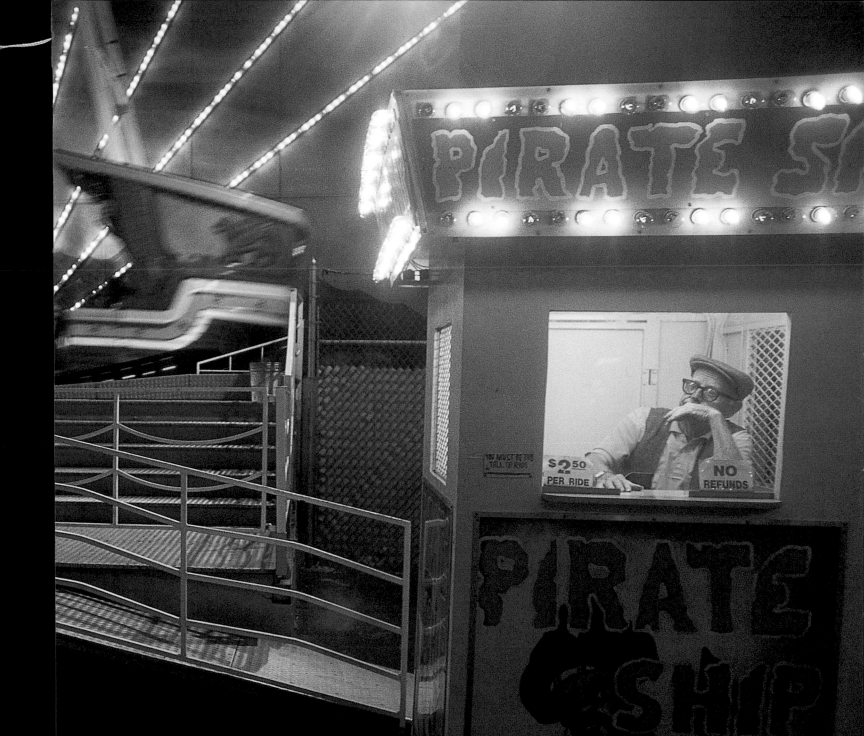

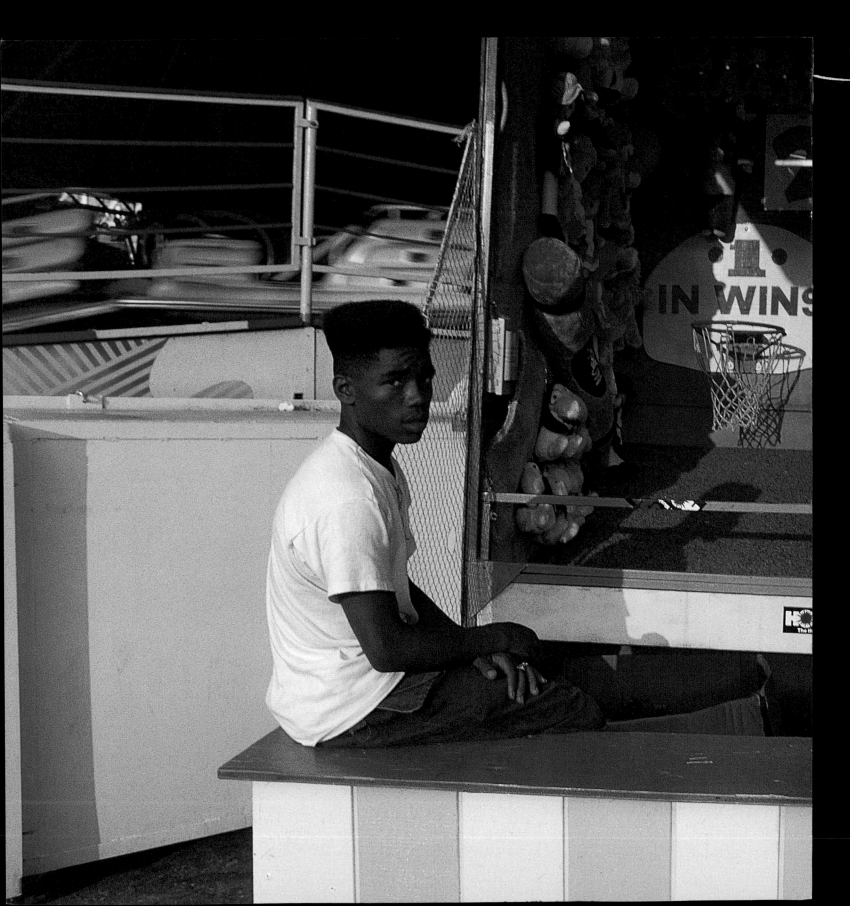

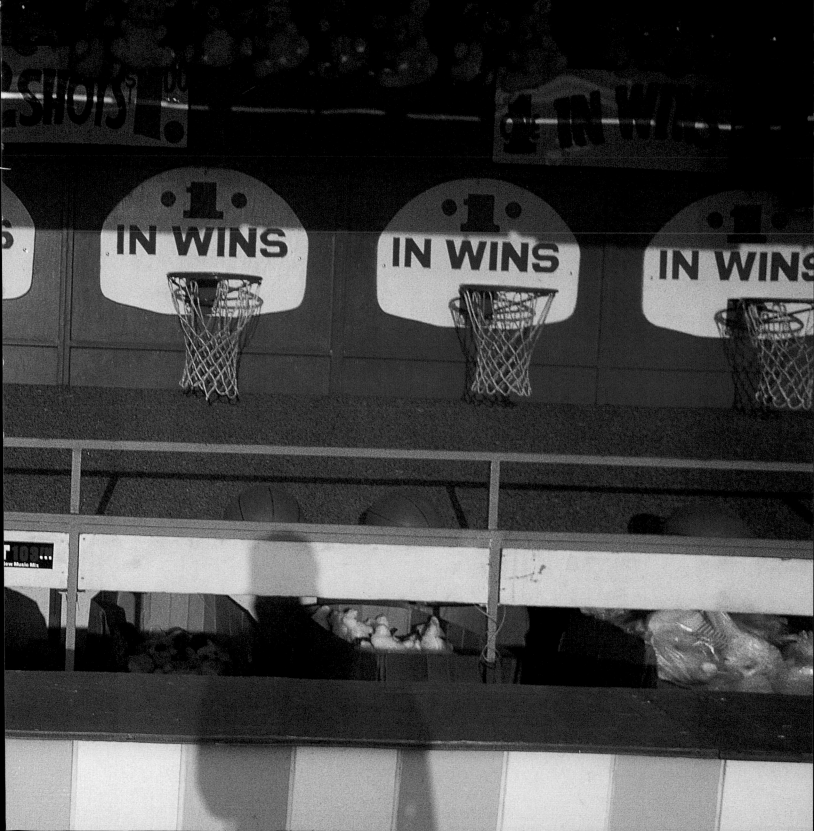

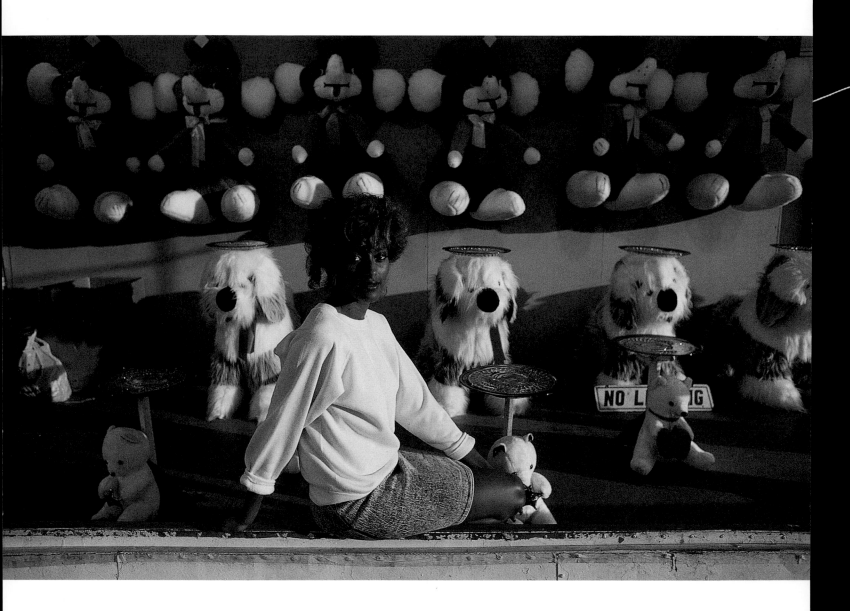

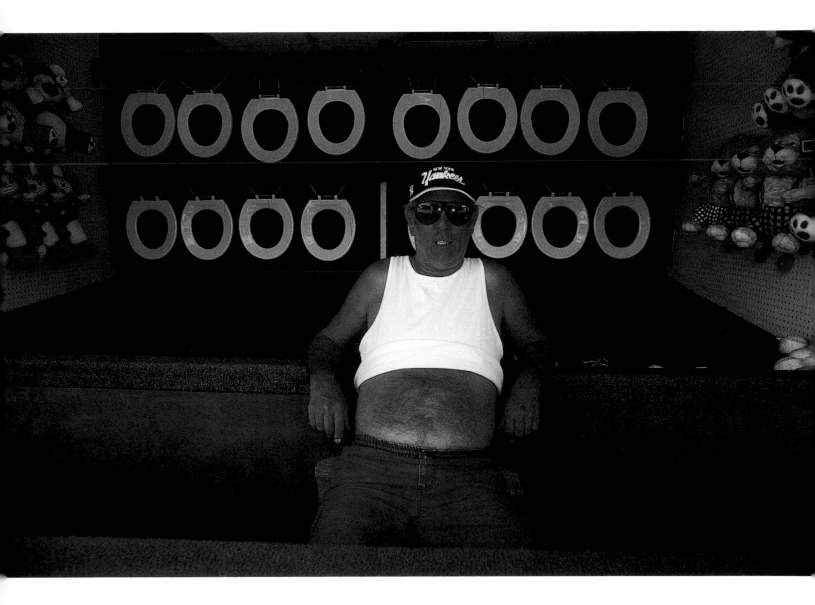

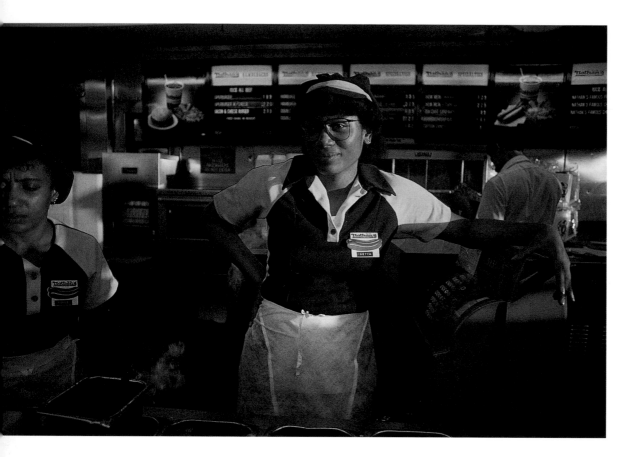

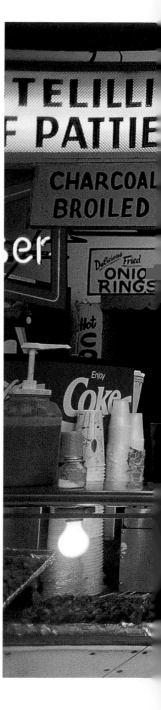

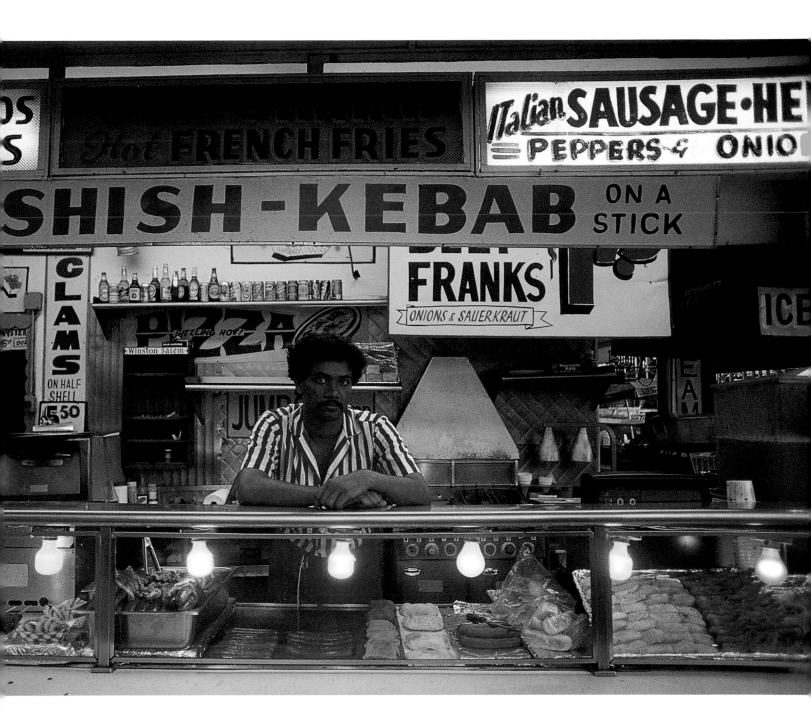

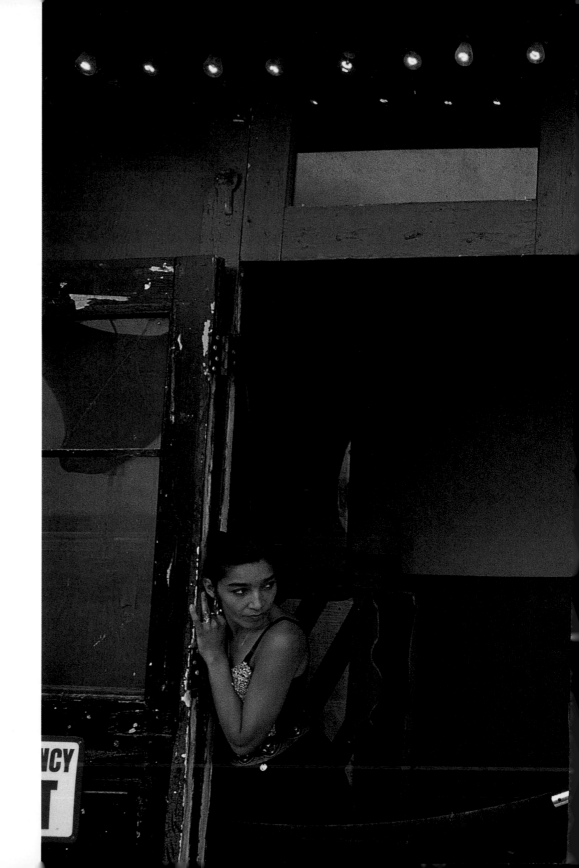

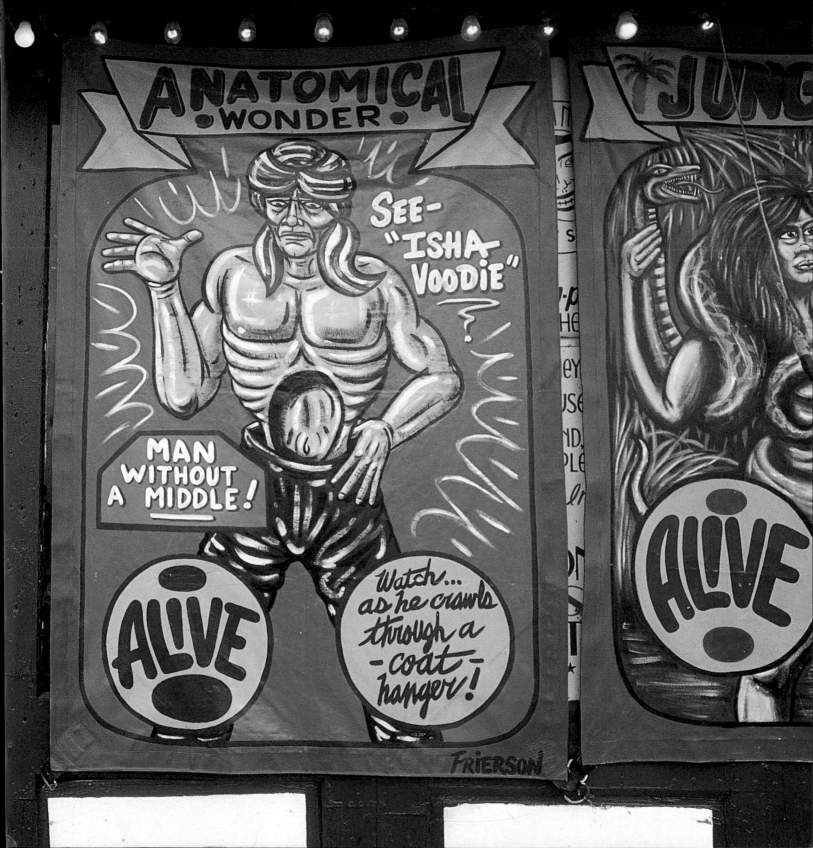

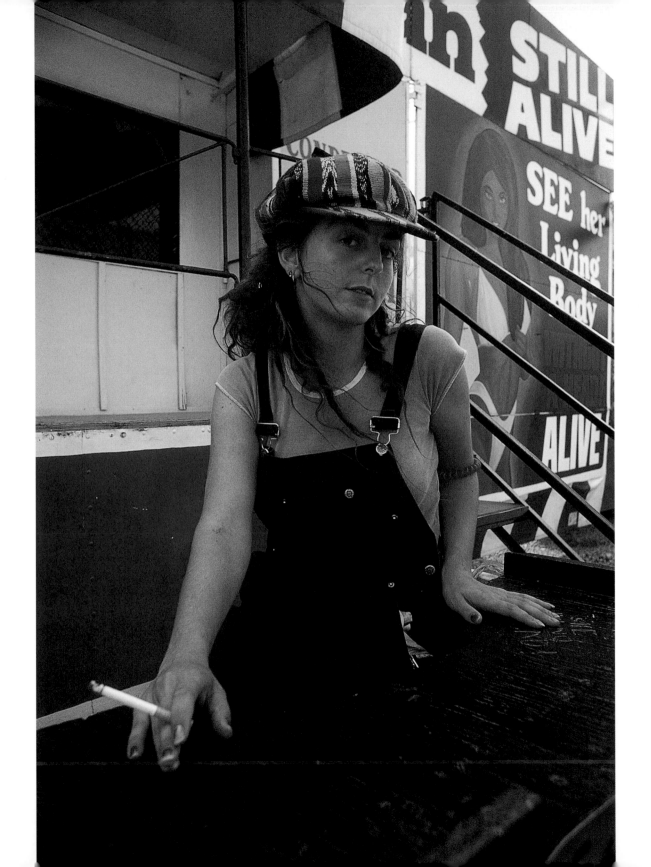

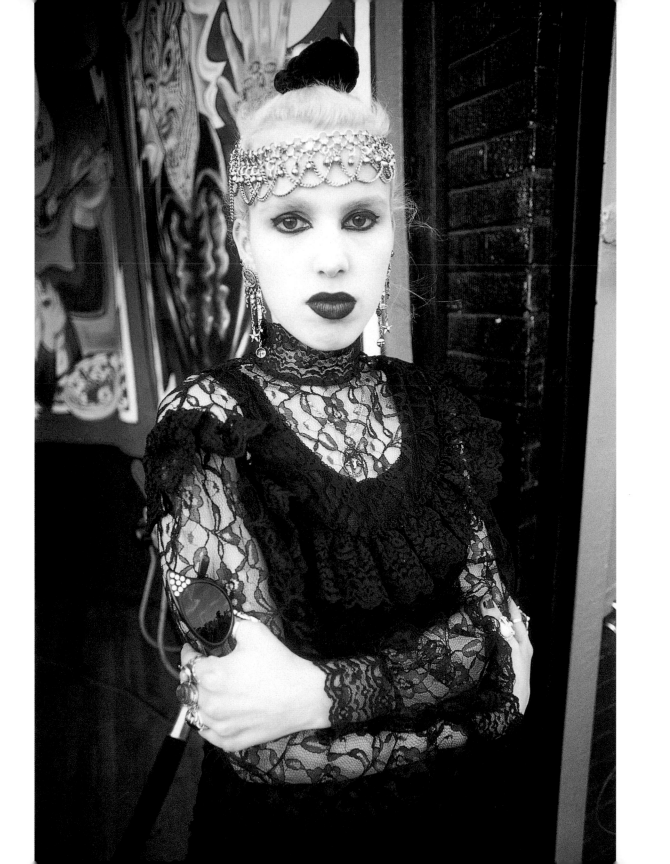

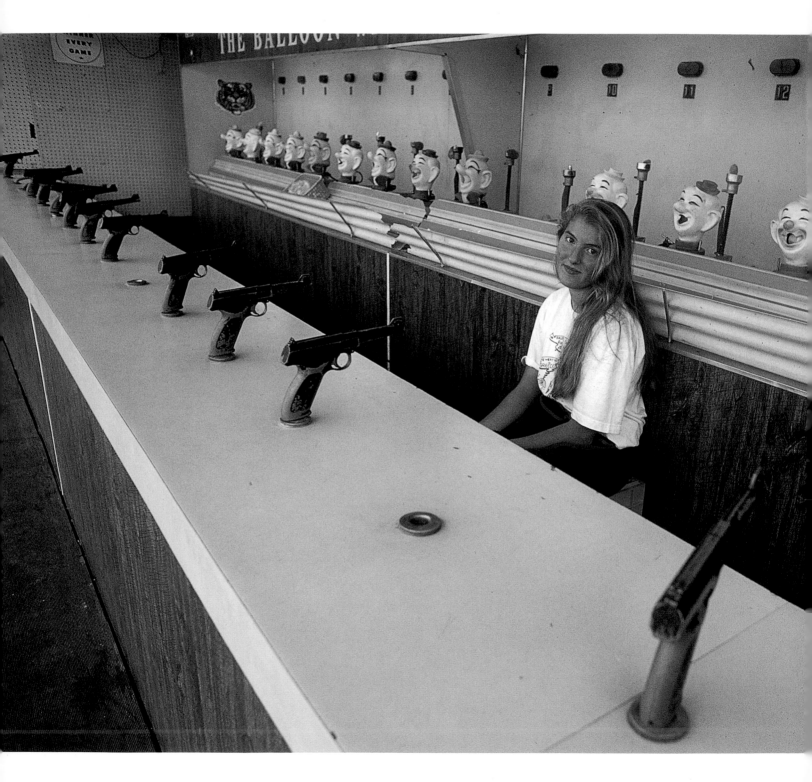

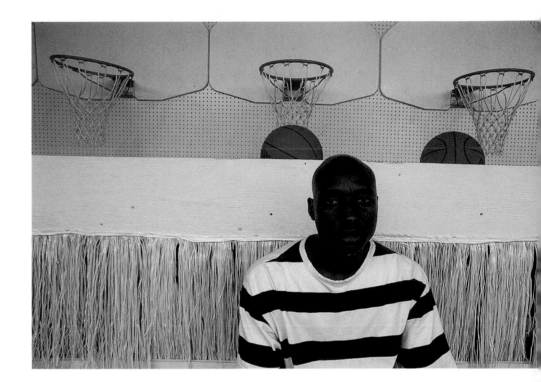

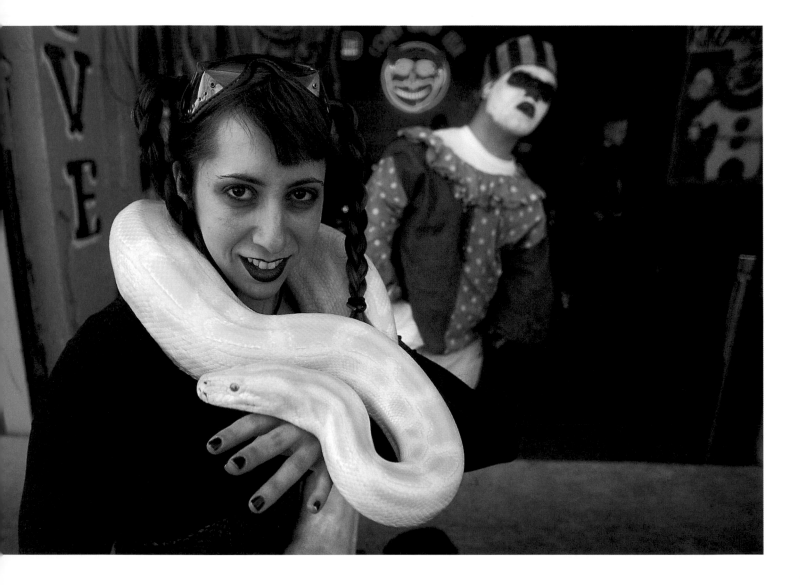

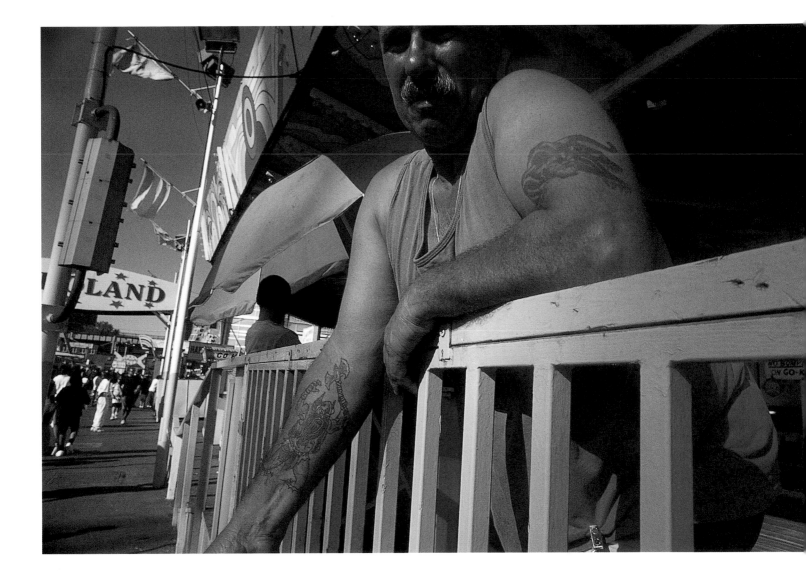

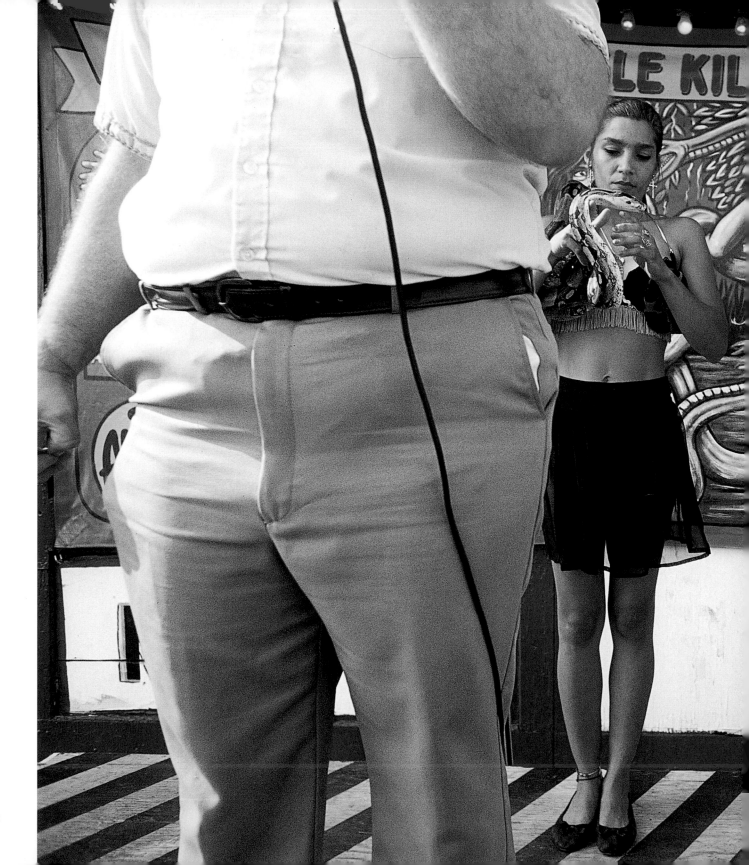

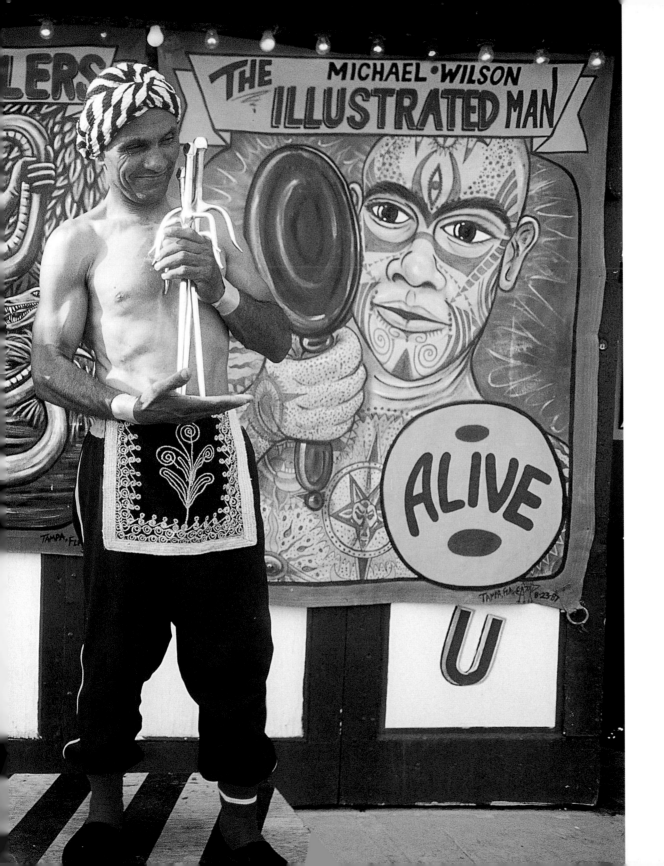

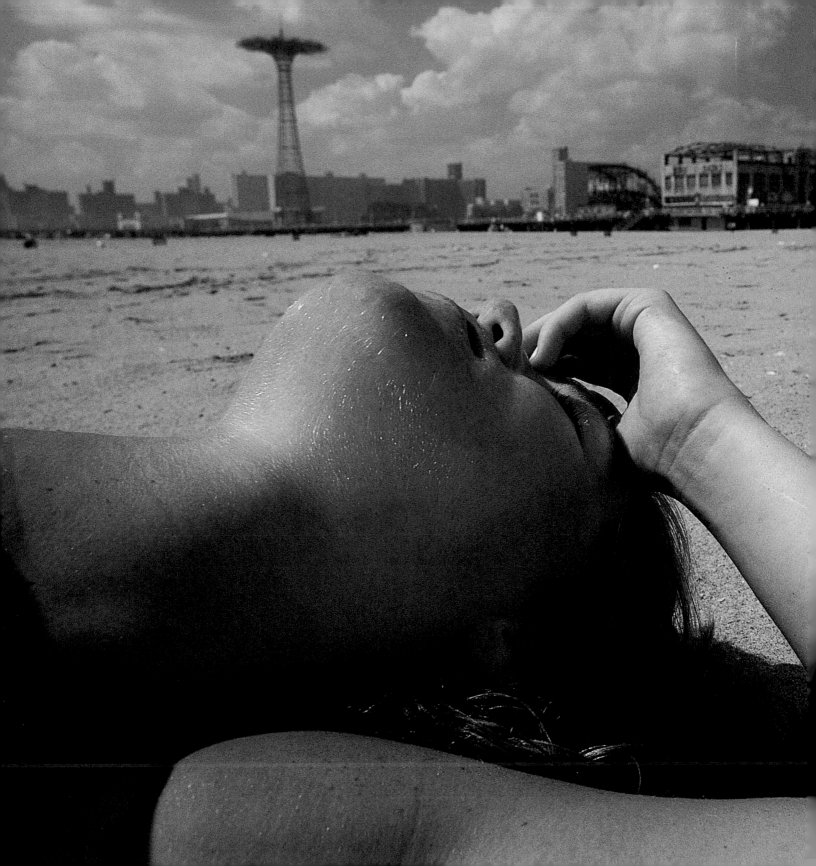

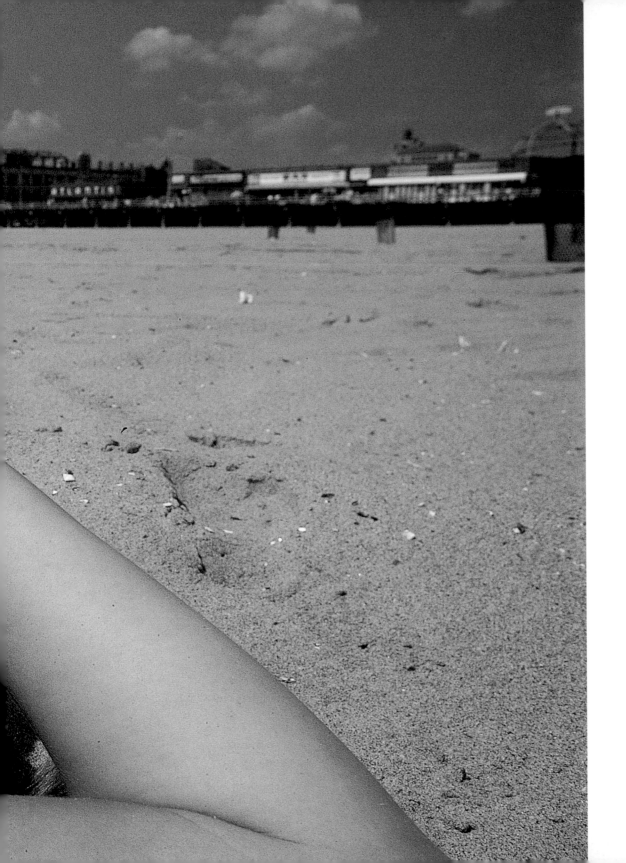

The Beach

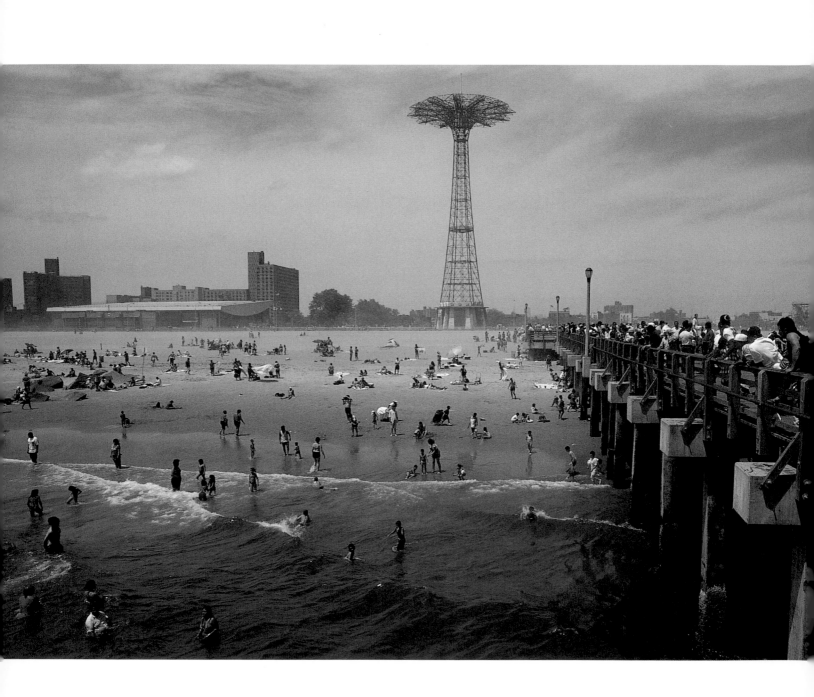

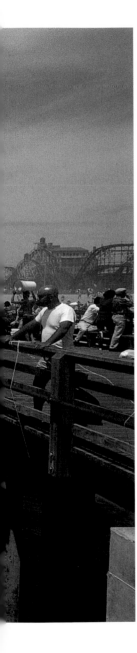

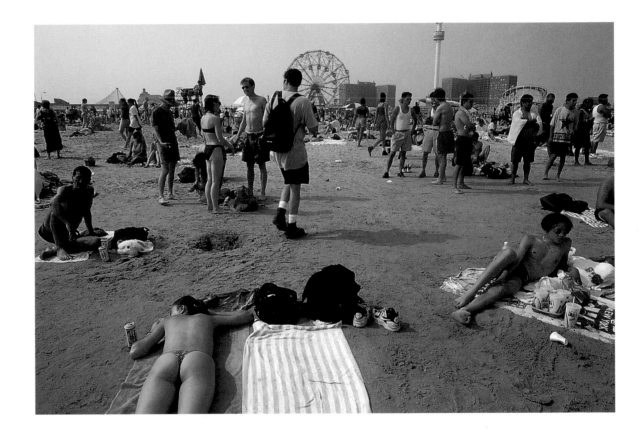

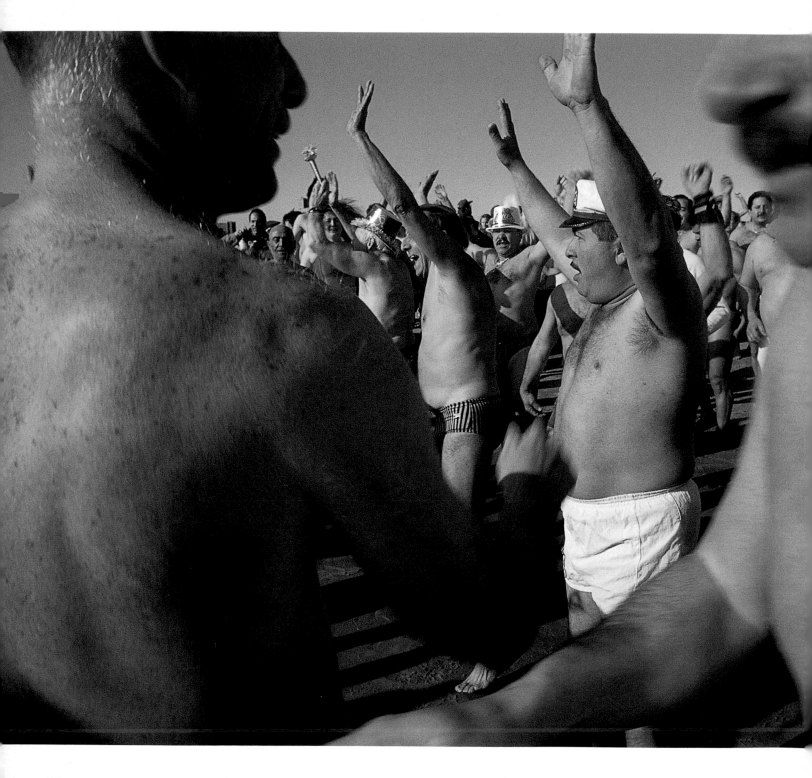

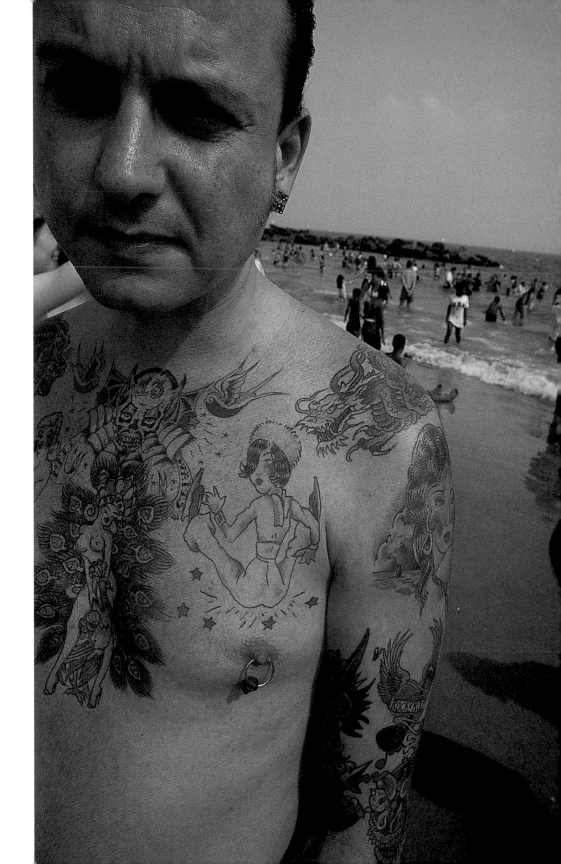

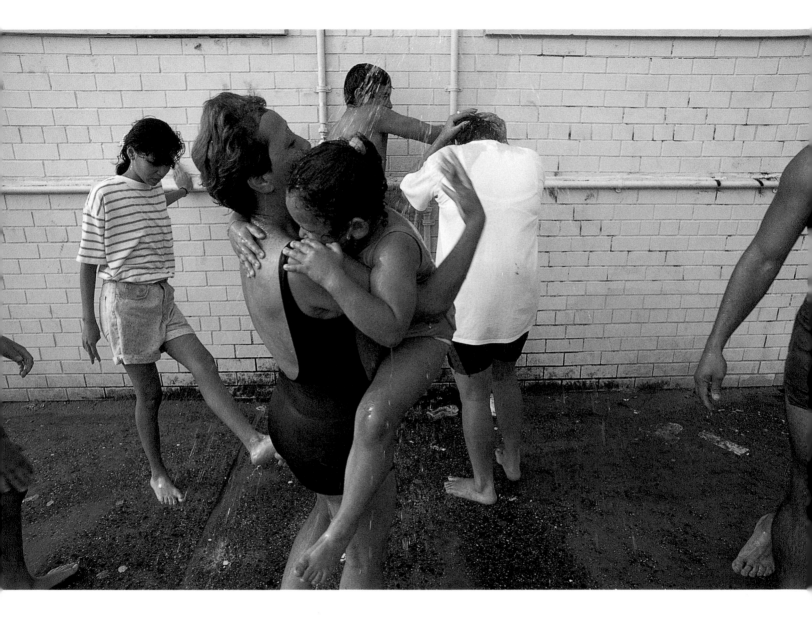

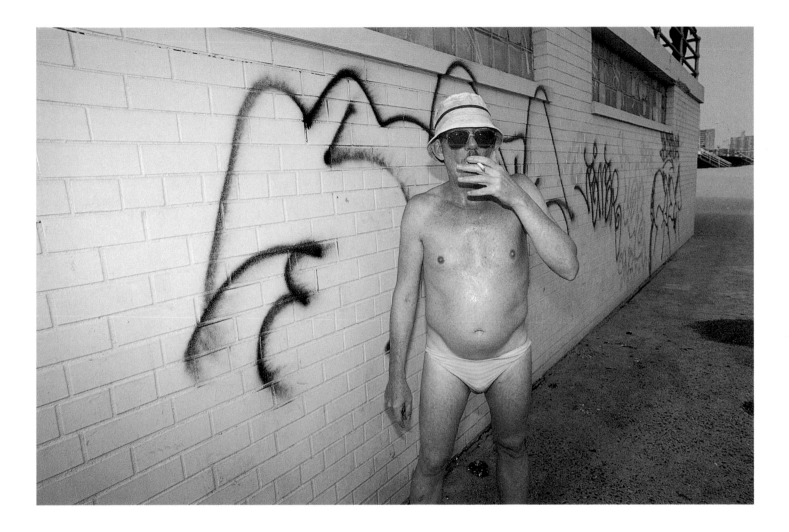

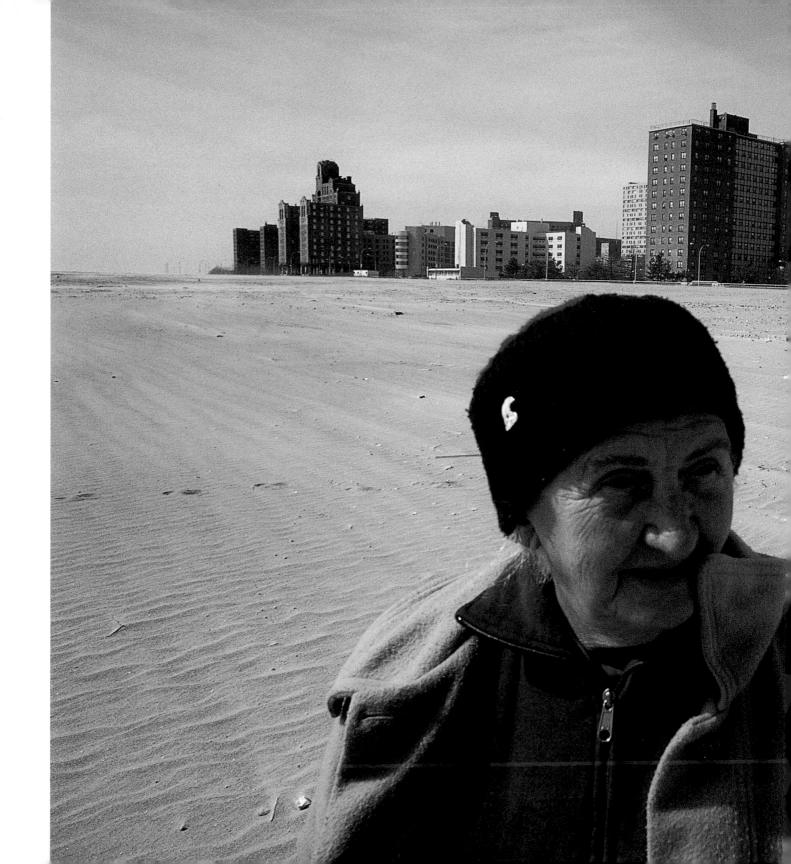

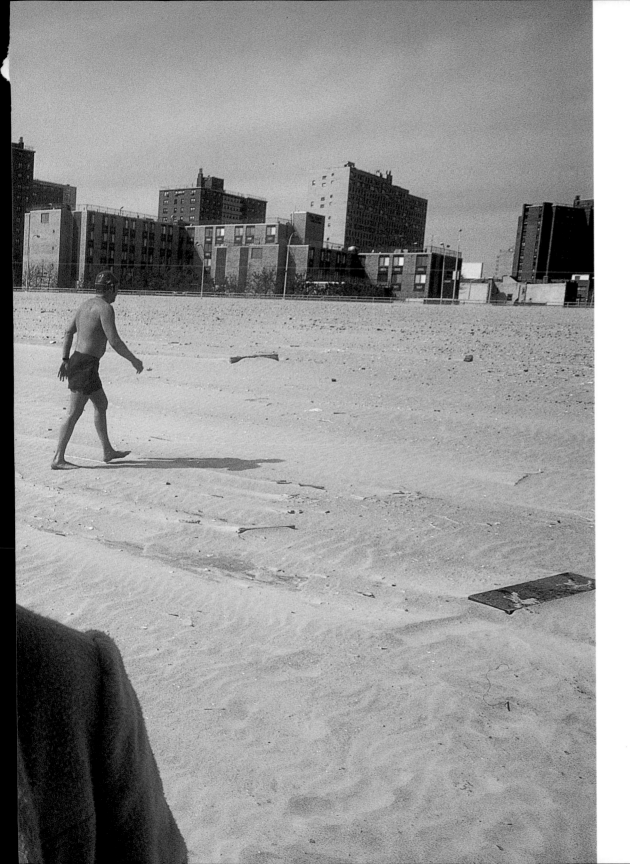

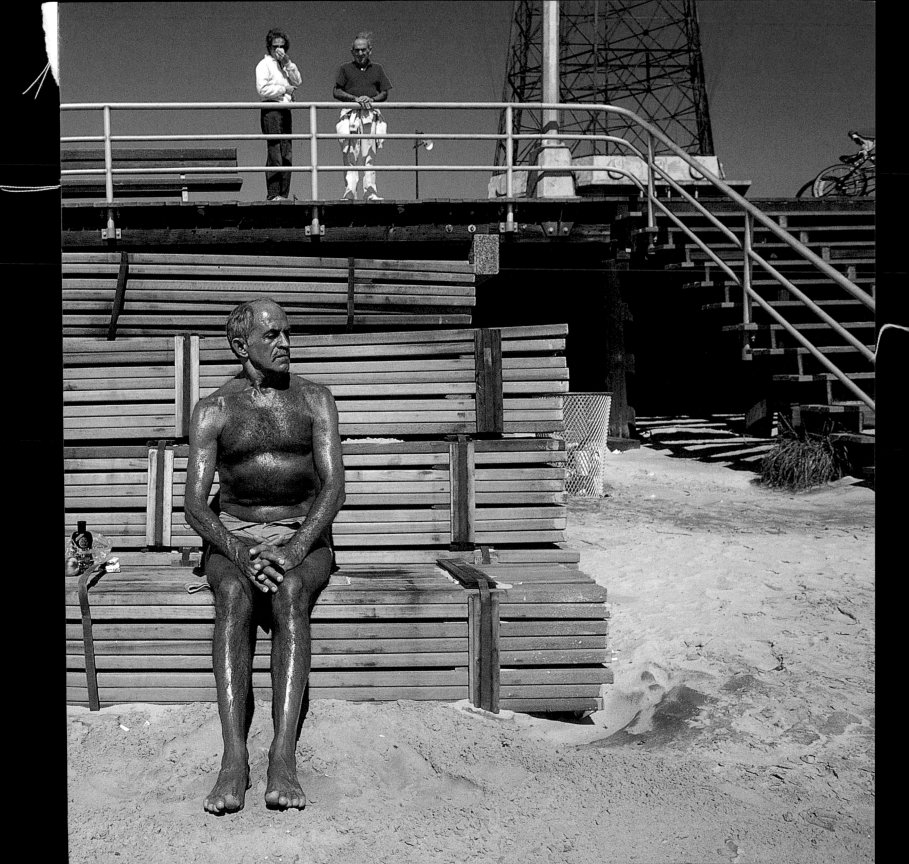

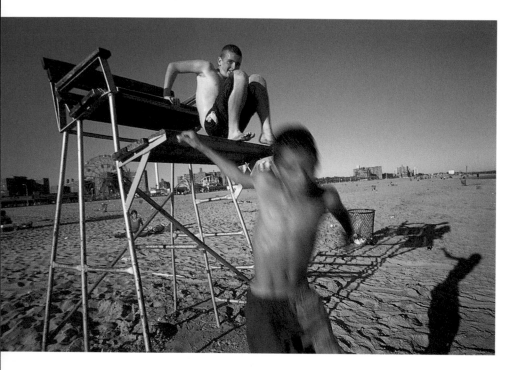

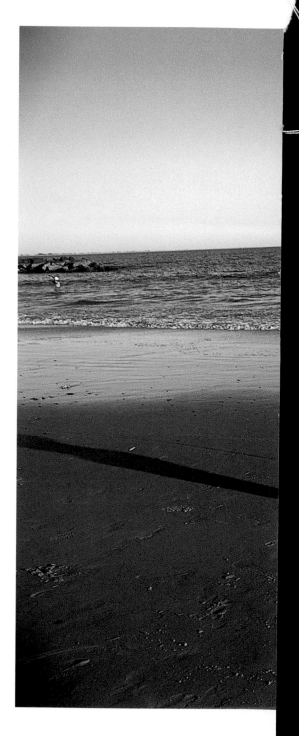

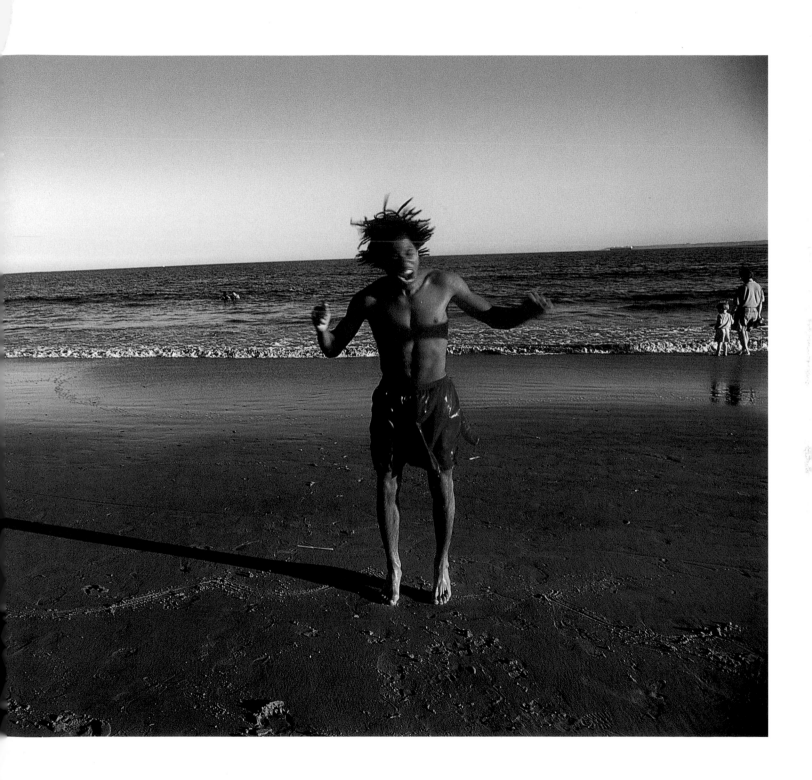

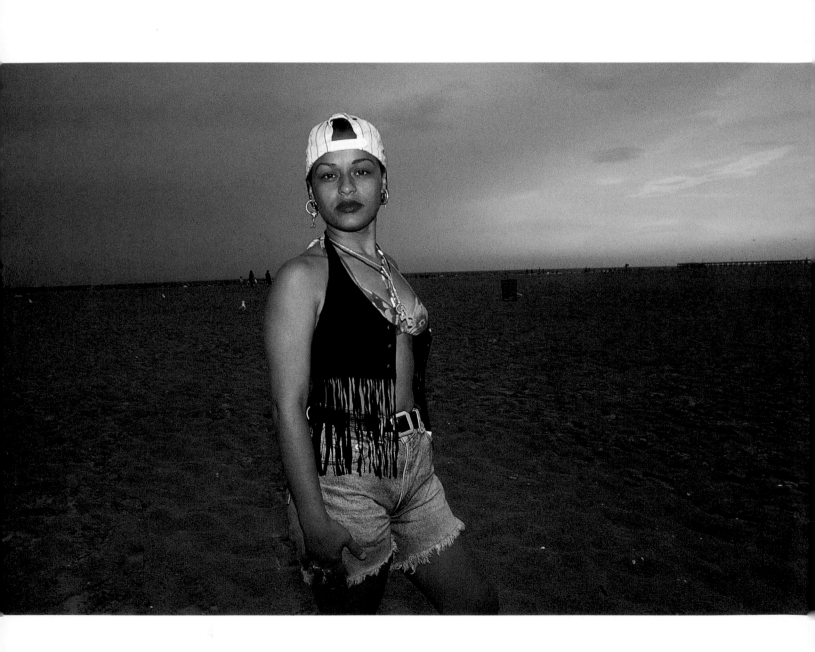

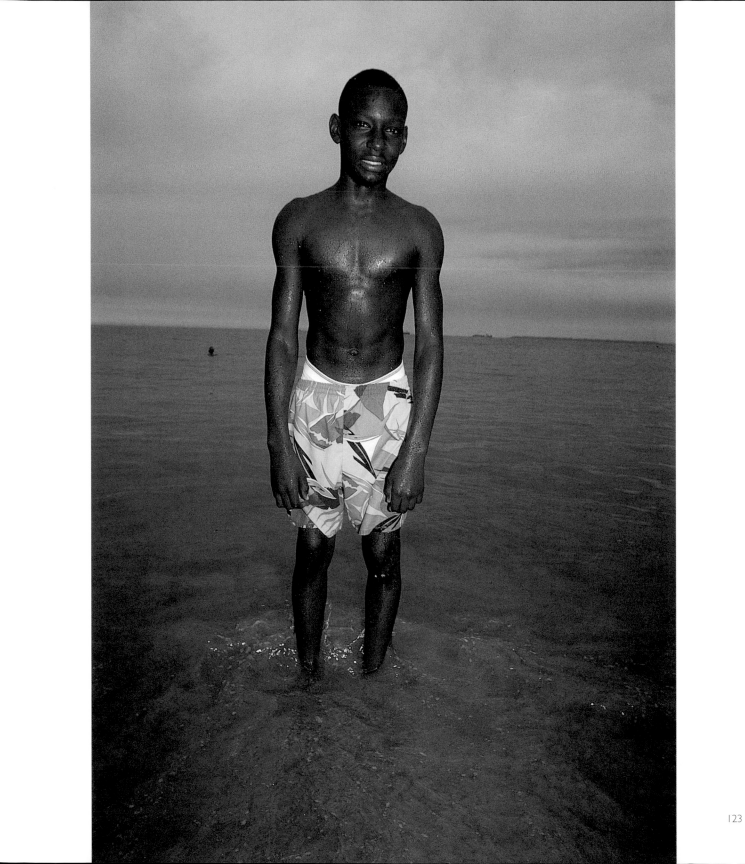

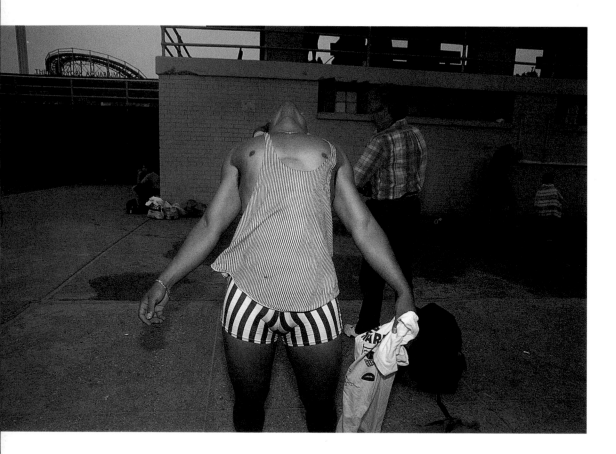

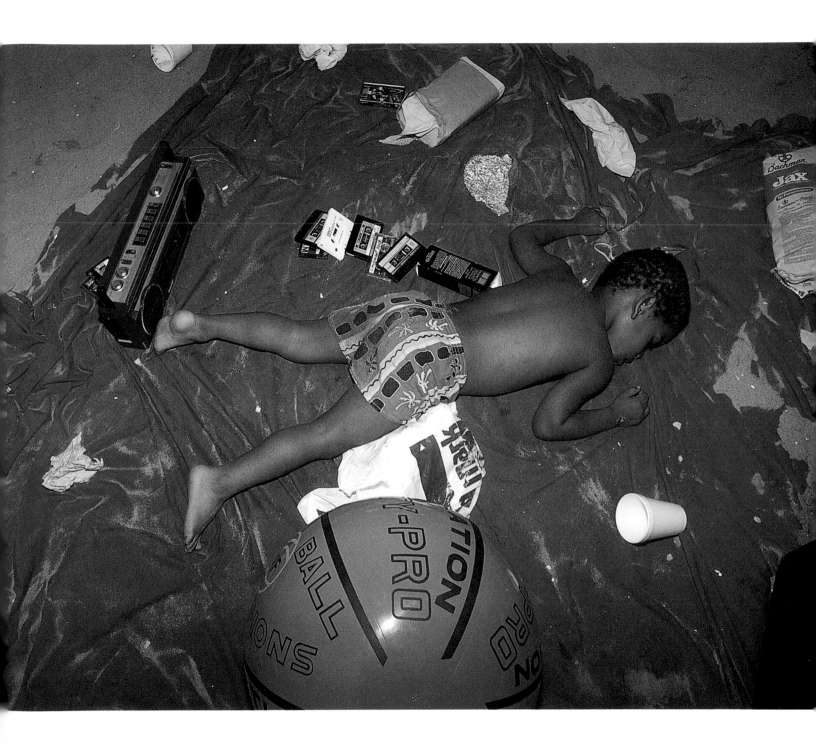

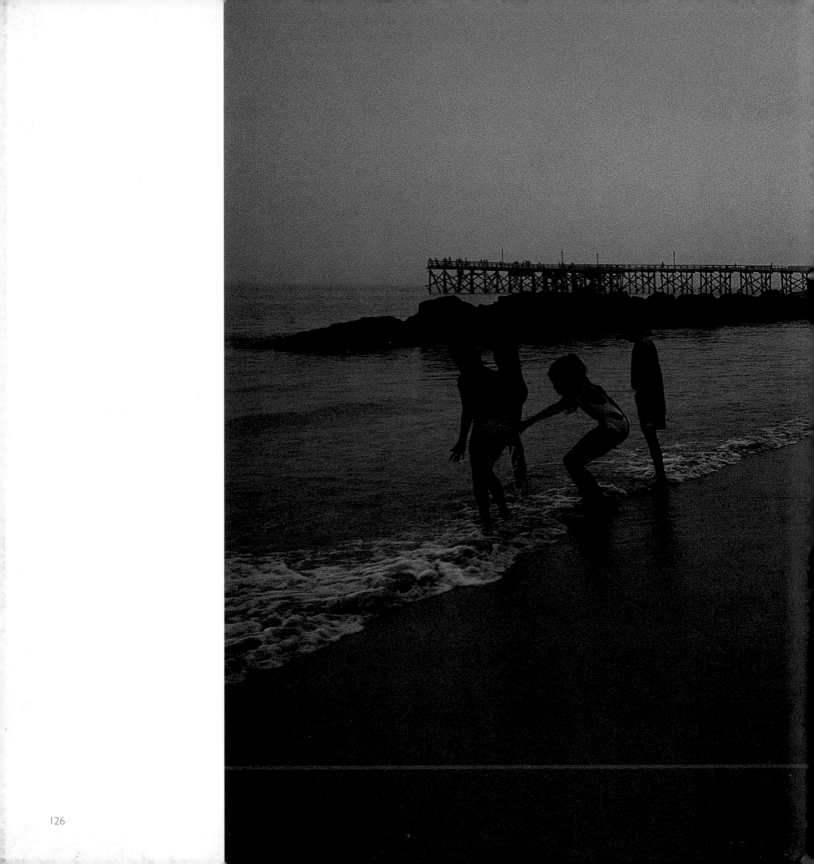

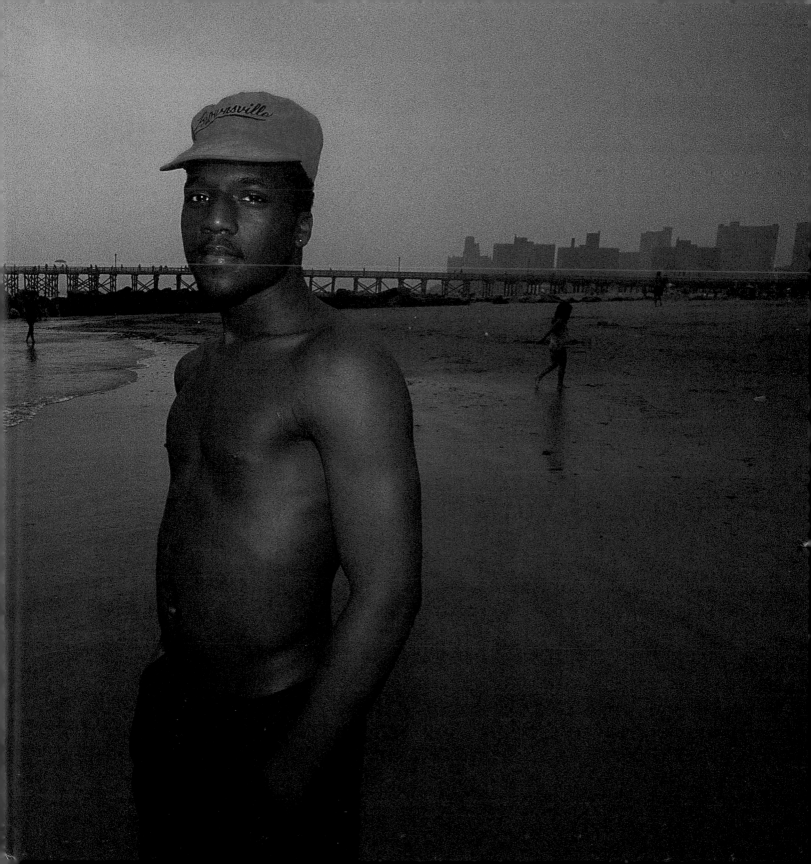

Any project as long-lived as this effort to photograph Coney Island inevitably incurs much gratitude along the way. The education staff of the International Center of Photography, my home away from home and where I've

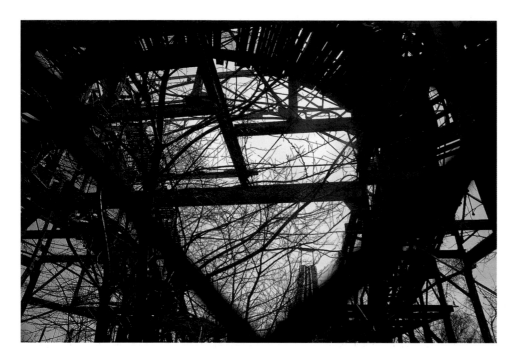

taught since 1976, has always been available for me to show and discuss the work. In particular, Phil Bloch and Suzanne Nicholas have been quite helpful and Donna Ruskin has been a good friend and insightful critic. Her comments have helped to edit and shape the work. Thanks are also due to the approximately one thousand students of ICP whom I've "dragged" to Coney over the years as part of my many classes; their awe, enjoyment, and fresh perspectives added to my enthusiasm. The late Via Wynroth, the first Director of Education at ICP and with whom I photographed at Coney Island, was always inspirational. We all miss her greatly and think of her often.

Ethyl Wolvovitz, a former student and now a terrific photographer, has occasionally accompanied me to photograph at Coney Island. Her wonderful sense of humor and love of the place has been contagious.

Dick Zigun, the founder of Coney Island USA and the Mermaid Parade and a tireless promoter of the riches of Coney Island, deserves all our praise for his faith in the history and the future of Coney. he and his able assistant, Sara Ruszcyk, have often paved my way to get to the right spot at the right time.

I owe much to Jim Mairs, my editor at W. W. Norton, who had faith in the work and made it happen in book form. His intelligence, fine editorial direction, and wise council has guided me through the bookmaking process with a minimum of anxiety and pain. Thanks to Katy Homans for her beautiful book design; to Irwin Cohen and Burt Scherman, chairman and president, respectively, of Cableview Publications, for their generous contribution of computer-scanned proof prints; and to John Manbeck, Historian for the Borough of Brooklyn, for the use of his Coney Island time line.

Finally, my unending thanks to my partner, Hilda Chazanovitz, who has had to bear the brunt of my frequent absences, constant talk about Coney Island, and many slide shows to help review the work. Without her, all this would be less meaningful and less worthwhile. —HS

Acknowledgments